EDVARD MUNCH
Starry Night

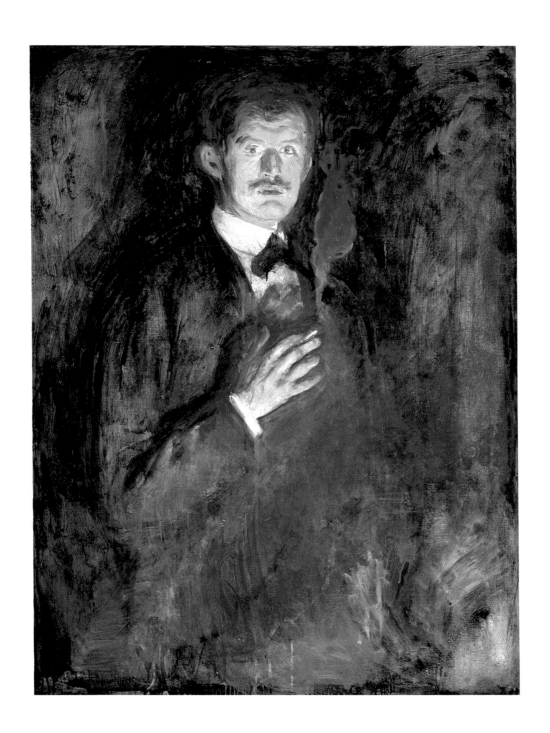

EDVARD MUNCH
Starry Night

Louise Lippincott

GETTY
MUSEUM
STUDIES
ON ART

MALIBU, CALIFORNIA 1988

©1988 The J. Paul Getty Museum
17985 Pacific Coast Highway
Malibu, California 90265-5799

Mailing Address:
P.O. Box 2112
Santa Monica, California 90406

Library of Congress
Cataloging-in-Publication Data

Lippincott, Louise, 1953–
 Edvard Munch, Starry night / Louise Lippincott.
 p. cm. — (Getty Museum studies on art)
 Bibliography: p.
 ISBN 0-89236-139-5
 1. Munch, Edvard, 1863–1944. Starry night. 2. J. Paul Getty
Museum. I. Title. II. Series.
 ND773.M8S735 1988 759.81—dc 19 88-13061

Cover, foldout: EDVARD MUNCH (Nor-
wegian, 1863–1944). *Starry Night*, 1893. Oil
on canvas, 135.2 × 140 cm (53⅜ × 55⅛ in.).
Malibu, J. Paul Getty Museum 84.PA.681.

Frontispiece: EDVARD MUNCH. *Self-Portrait
with Cigarette*, 1895. Oil on canvas, 110.5 ×
85.5 cm (43½ × 33¹¹⁄₁₆ in.). Oslo, Nasjonal-
galleriet 470.

CONTENTS

FOREWORD

THIS BOOK, LIKE SO MANY THINGS THE GETTY MUSEUM UNDERTAKES, represents a new effort. It is the first in a series of short books that will examine important single works of art from various points of view. Each subject will be chosen from our collection on the basis of its distinctive visual power, historical interest, and richness of meaning.

We launch this series with a study of one of our most enigmatic pictures, Edvard Munch's *Starry Night*. Ever since it was hung in the galleries in 1985, this picture has attracted and perplexed our visitors. They recognize the subject, yet are unsettled by its flattening and distortion in a way that seems consciously intended by the artist. The painting resonates with associations with other works of art, including the better-known picture of the same title by van Gogh. At the same time, it is saturated with meanings that flow from the rich and often tormented inner life of Munch himself.

The method of this essay by the Museum's associate curator of paintings is especially effective, we think. We hope that this book and its successors will not only illuminate works of art but also make various approaches vivid for our audience. We want to cast a wide net that will assure a fresh supply of meanings.

John Walsh
Director

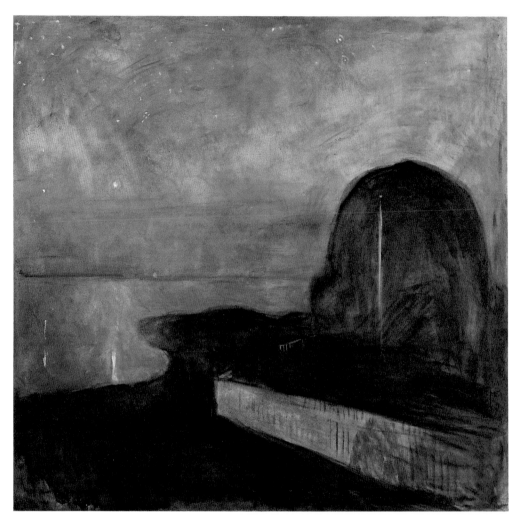

Figure 1. EDVARD MUNCH (Norwegian, 1863–1944). *Starry Night*, 1893. Oil on canvas, 135.2 × 140 cm (53⅜ × 55⅛ in.). Malibu, J. Paul Getty Museum 84.PA.681.

Introduction: *Starry Night* as Emotional Experience

All in all, art results from man's desire to communicate with his fellows. All methods are equally effective. Both in literature and in painting the technique varies according to the aims of the artist. Nature is a means to an end, not an end in itself. If it is possible to produce the desired effect by changing nature, then it should be done. A landscape will alter according to the mood of the person who sees it, and in order to represent that particular scene the artist will produce a picture that expresses his own personal feelings. It is these feelings which are crucial: nature is merely the means of conveying them. Whether the picture resembles nature or not is irrelevant, as a picture cannot be explained; the reason for its being painted in the first place was that the artist could find no other means of expressing what he saw. The finished work can only give a hint of what was in the artist's mind.

—Edvard Munch[1]

THE EXPRESSION OF A VISION, the communication of a mood—these are the goals of Edvard Munch's landscape paintings, of which *Starry Night*, executed in 1893, is an outstanding example (cover, foldout, fig. 1). The central mystery of this painting is the nature of the personal feeling it represents or evokes. Munch himself (see frontis.) confessed that, although he could best express his feelings in paintings, they merely hinted at the true character and force of his emotions. Consequently, to write about the visions or moods in his art, or even to read about them, is very different from experiencing them in front of the canvases themselves. Direct confrontation with *Starry Night* can be an exhilarating, if troubling, experience on many levels. The lack of obvious subject is one problem. What does this nearly abstract composition represent? A second problem is the painting's style, which at first glance seems almost embarrassingly simple and direct, and which is far removed from the Realist or Impressionist modes that characterize nineteenth-century painting in the popular

imagination. Thirdly, there is the problem of emotional response, whether it be baf-flement, unease, foreboding, or mystical rapture (to mention only a few possibilities). Few viewers can dismiss this stark and powerful image altogether.

Starry Night's undeniable impact proves that with this picture, at least, the Norwegian artist achieved his goal: to communicate with his audience in a psycho-logically direct and broadly empathetic manner. This was not a goal he achieved easily, and in fact *Starry Night* is one of the first landscape paintings in which he may be said to have done so. In the years leading up to its execution, he had to master (to some extent) his own complicated and turbulent emotional life; he had to discover the actual place that in some way resonated with his feelings about that life; and he had to de-velop an artistic vocabulary that could express his emotional state. These develop-ments were intensely personal, worked out in psychological and at times physical iso-lation during his wanderings among the great cities of Europe. His breakthrough only occurred in the early 1890s, culminating in his famous Frieze of Life series, with which *Starry Night* was associated for a time.

The history of *Starry Night* after Munch painted it in 1893 touches on yet another issue inherent in his view of landscape, namely his opinion that it was subject to the moods and memories of its observer. Thus while the Getty Museum's com-position is arguably Munch's finest early landscape, it could never be viewed as his definitive response to the subject. Just as Monet's *Haystacks* record changes in a land-scape resulting from changes in weather, light, and season, so Munch's later versions of *Starry Night* portray a landscape altered by the artist's shifting moods and recent experience. The mood and content of Munch's later nocturnal landscapes vary be-tween two extremes: exultation in the beauty of a landscape he loved deeply, and pessimism resulting from his sense of personal loneliness and artistic isolation. Un-raveling these later versions, their associations and their symbolism, further illumi-nates the significance of the founding version. *Starry Night* must be understood as the embodiment of a continuing theme in the development of Munch's psychological land-scape. It represents an end of one process: his search for formal means with which to express his inner, emotional life. It also marks the beginning of a second development: his manipulation, reexamination, and reformulation of these emotional associations in

subsequent works of art formally or thematically related to the Getty Museum's painting. While *Starry Night*'s emotional impact on each viewer remains essentially private and mysterious—as the artist wished—some sense of the effect he desired to achieve can be found in the consideration of this painting as a landmark in his artistic and spiritual life.

Origins: Landscapes of Mood and Memory

IN THE LATTER HALF OF THE NINETEENTH CENTURY, Scandinavia began
to play an active role in European and international affairs for the first time in cen-
turies. The new liveliness of Scandinavian culture derived from the region's steadily
growing material prosperity. Shipping, timber, and hydroelectric power transformed
the economies of Norway and Sweden in the last quarter of the century, creating
enough wealth in the upper middle and aristocratic classes to support daily newspapers,
serious literature, the theater, art exhibitions, and the collecting of modern art. In 1871
the Danish writer and critic George Brandes had prepared a series of lectures in Co-
penhagen entitled *Main Currents in Nineteenth-Century Literature* which launched a cul-
tural movement later called the Scandinavian Renaissance.[2] Brandes described the
latest artistic movements on the Continent, especially the naturalism of the novelist
Emile Zola, and advocated the adoption of this new style in Scandinavia. Brandes was
one of the first to recognize and appreciate the greatness of poet and dramatist Henrik
Ibsen, and his appeal for cultural radicalism and innovation jolted Scandinavian artists
out of their complacent mid-century romanticism. So began a long and painful process
of searching and experimentation. Yet within twenty years—coincidentally with Nor-
way's struggle for political and economic independence—Edvard Munch emerged as
Scandinavia's greatest painter and a founder of European modernism.

Since the eighteenth century Scandinavian artists and writers had traveled in
search of either training or success abroad. To provincial Scandinavian audiences, in-
ternational success was almost a prerequisite for recognition at home. Artists had often
found success easier to obtain and materially more rewarding on the Continent, too.
The Norwegian landscape painter Johann Christian Dahl, who settled in Germany,
and Ibsen, who lived in Italy and Germany from 1867 to 1891, are two famous ex-
amples of a common phenomenon that persisted into the twentieth century. In the

words of the Norwegian naturalist painter Gustav Wenzel, "[T]his is the same bitterness which makes those who live at home only long to get out, while those who are abroad pray to God to deliver them from ever having to live at home."[3] Beginning in the late 1870s, more and more Scandinavian painters headed toward Paris rather than Munich, Berlin, or Rome. There they formed a visible and successful artistic colony throughout the 1880s. Although they enrolled in established art schools, and preferred to exhibit in the official Salons, they also saw the work of Monet, Pissarro, Caillebotte, Manet, Bastien-Lepage, and Raffaëlli. The influence of these French painters, who were the most admired in Scandinavian circles, transformed Scandinavian painting. It became brighter in color, lighter in tone, and freer in execution, with an increased concentration on scenes of contemporary life. To use Norwegian artist Christian Krohg's work as an example of the extent of French influence, one need only compare his *Village Street in Normandy* (fig. 2) with its prototype by Caillebotte, *Street in Paris; Rain* (1877; Art Institute of Chicago).[4] Krohg's rising street, steep perspective, abbreviated foreground figures, and light gray coloring all stem from the earlier French painting. Similarly dependent, in this case on Courbet and Bastien-Lepage, is Erik Werenskiold's *Country Funeral* (fig. 3), with its monumental peasant subject taken from Courbet's *Burial at Ornans* (1849; Paris, Musée d'Orsay). Although the new style blended several aspects of recent French painting—realism, naturalism, pleinairism, even impressionism—the Scandinavians equated it with the naturalism of contemporary literature, especially the work of Zola. Thus their conception of naturalist painting incorporated truthful representation not only of the visible world but also of human nature and psychology.

This was the style Edvard Munch learned from Christian Krohg after he entered the art school that Krohg ran in collaboration with the landscape painter Fritz Thaulow (in 1882) and (after 1885) with Erik Werenskiold and Hans Heyerdahl. Up to this point, the eighteen-year-old art student had enjoyed only one year of formal training, at the conservative design school at Christiania (present-day Oslo), although he had practiced drawing and painting since adolescence. He rapidly changed his style to follow Krohg's lead into naturalism, and within two years his brushwork in paintings such as *Girl Kindling the Stove* (1883; private collection) or *Morning* (1884; Bergen, Ras-

13

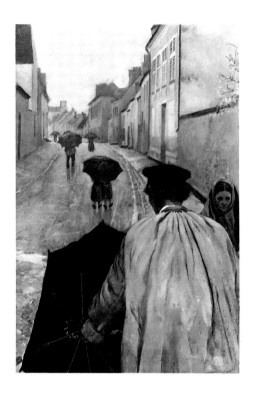

Figure 2. CHRISTIAN KROHG (Norwegian, 1852–1925). *Village Street in Normandy*, 1882. Oil on canvas, 102 × 70 cm (40 3/16 × 27 9/16 in.). Bergen, Rasmus Meyers Samlinger.

mus Meyers Samlinger) had become even freer than Krohg's. Characteristically, Munch's interest in light, color, and texture already outweighed the concern for topicality that was the dominant feature of his master's work. His artistic tendencies may have been encouraged by Fritz Thaulow, a specialist in capturing the effects of light on water. Although in 1884 Munch turned down Thaulow's offer of a scholarship for travel to Paris, he painted at the older artist's open-air academy at Modum that September (see fig. 4). Thanks to the influence of his teachers, Munch was committing himself to Continental avant-garde painting. Comments he made after exhibiting his work at the Autumn Exhibition in Christiania reveal a certain disdain: "Well, now our great 'salon' is over, and the impression I am left with is insipid. It was beyond all description worthy Norwegian worthiness. Not a single picture has left behind an impression comparable with a few pages of an Ibsen drama."[5]

14

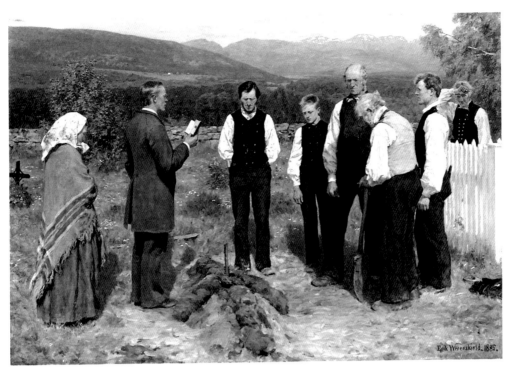

Figure 3. ERIK WERENSKIOLD (Norwegian, 1855-1938). *Country Funeral*, 1883–1885. Oil on canvas, 102.5×150.5 cm (40⅜×59¼ in.). Oslo, Nasjonalgalleriet 320.

1884 was also the year in which Norway achieved parliamentary rule after decades of struggle. Although the country had won independence from Denmark seventy years earlier, its weakness had forced it to accept Swedish protection and Swedish government. The leadership in the struggle came not only from radical politicians—headed by the new prime minister, Johann Sverdrup—but also from Norway's most prominent writers and artists, who hoped for cultural as well as political independence.

Not surprisingly, the 1884 election victory and an outburst of nationalistic excitement affected the Norwegians' view of the local landscape, which was well on the way to becoming their "own." The leading Norwegian landscapists had assimilated the influence of Bastien-Lepage, Monet, and Puvis de Chavannes, of the Amer-

15

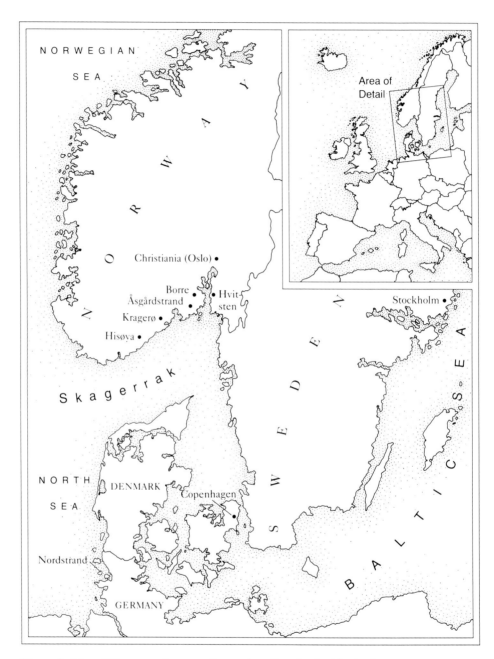

Figure 4. Map of Norway and surrounding region. Drawing by Martha Breen.

icans Whistler and Sargent, and of the Swedes, and they were exhibiting successfully in Paris and Christiania. But in 1886, they broke their habit of summering in foreign artists' colonies and returned to Norway to paint together at a farm called Fleskum. That summer Harriet Backer, Kitty Kielland, Eiliff Peterssen, Christian Skredsvig, Erik Werenskiold, and Gerhard Munthe created a distinctly Norwegian interpretation of a late nineteenth-century phenomenon, the mood landscape. Eiliff Peterssen's exemplary *Summer Night* (fig. 5) represents the Fleskum pond at that quintessentially Scandinavian "blue hour" of twilight which in summer actually stretches well into the night. To Norwegians, the lush vegetation and lingering daylight fused with moonlight represented the most lyrical and inviting aspects of their harsh environment. The cool, clear light and crisp atmosphere are like nothing found in the softer French climate. Yet Peterssen's style and technique are based on Continental plein air painting. His restricted palette, dominated by shades of blue and green, derives ultimately from Whistler, Puvis, and Bastien-Lepage; the parallel brushstrokes describing the lake's reflective, still surface timidly suggest a familiarity with Monet. The fussily drawn trees and debris at the water's edge remain comfortably close to Bastien-Lepage. The Fleskum paintings, which defined the mood landscape, found critical and public success in Norway as soon as they were exhibited. The formula of prettiness, stylistic conservatism, nationalistic subject, and romantic melancholy proved to be irresistible.

Some Scandinavian painters harbored the hope that these celebratory views of Norway's landscape might soon be succeeded by naturalistic pictures advocating—or reflecting—social and cultural reforms. With the journalist and anarchic freethinker Hans Jaeger, Christian Krohg stood at the center of a radically inclined bohemian group in Christiania that also included Edvard Munch. By writing naturalistic novels and illustrating them with important paintings, these bohemians soon proved that the parliamentary radicals, not to mention the public at large, were more conservative than had been imagined. Despite his membership in the bohemians' circle, Munch never shared their commitment to cultural activism beyond the activism inherent in his own work. Nonetheless he could not help being drawn into their social experiments, in which each attempted to live according to the standards of sexual freedom promoted in their books. For example, Krohg and Jaeger, with Krohg's student Oda Engelhart,

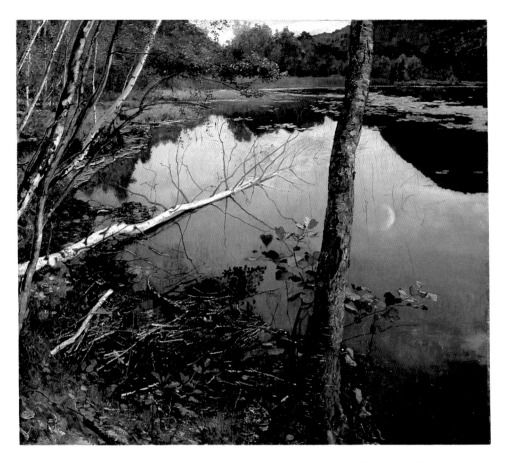

Figure 5. EILIFF PETERSSEN (Norwegian, 1852–1928). *Summer Night*, 1886. Oil on canvas, 133 × 151 cm (52 3/8 × 59 7/16 in.). Oslo, Nasjonalgalleriet 2745.

conducted an experiment in free love which failed after three years of mutual jealousy and torment. (Krohg and Engelhart married in 1888.)

In 1885 Munch embarked upon a social experiment of his own, an affair with Milly Ihlen Thaulow, his cousin's wife and a distant relative of the painter Fritz Thaulow. The affair, idealistic and serious on Munch's side, began in the small town of Borre near Åsgårdstrand in the summer of 1885. The first great event in the life he had yet to portray in art, it brought him inspiration, troubled joy, and long-lasting pain and disillusionment. The affair seems to have begun with a conversation between Munch and Milly Thaulow in the Grand Hotel at Åsgårdstrand. As Munch recalled several years later in a prose poem,

> They walked across the floor to the open window leaning out looking down in that garden It was chilly out there—The trees stood like big dark masses against the air It was *too* lovely—look there she pointed along the water between the trees
>
> Oh and up there is the moon—one is barely aware of it—it will emerge later
>
> I am so fond of the darkness—I cannot stand the light—it ought to be just like this evening when the moon is behind the clouds—it is so mysterious—The light is so indiscreet
>
> It is like this with me she said after a while—on evenings like this I could do anything—something terribly wrong
>
> Her eyes were big and veiled in the twilight . . .
>
> It was as if she meant something with it—he had a premonition that something was going to happen—[6]

This passage describes the view, and possibly even the moment, Munch eventually would paint in *Starry Night*. Other memories of this affair or moments in the continuing soap opera of bohemian life would resurface—transformed—in Munch's figure paintings of the early '90s.

In their search for a new art appropriate to their plans for a new society, the bohemians' watchword was "impressionism." To the Norwegians, as to many Europeans of the time, the term carried implications of social and artistic radicalism reminiscent of Manet and Caillebotte without too specific an association with the objective vision, broken brushwork, and brilliant colors that actually characterize the style. Wer-

enskiold described impressionism as "naturalism pushed farther, a more advanced conception of nature," while Christian Krohg identified it with the work of the French painter Manet, the German Max Klinger, and the Swiss Arnold Böcklin, none of whom is considered typical of the movement today.[7] What these artists shared, and what Krohg seems to have accepted as impressionist, were their reputations as rebels against academic or official artistic establishments. The young Munch seems to have considered himself an impressionist painter during these years. Judging from his most important, breakthrough work of the time, *The Sick Child* (fig. 6), he apparently thought of impressionism as radicalized naturalism. So, if Krohg showed the viewer peasants or urban workers in the guise of democratic heroes, Munch confronted his audience with prostitutes, decadent bohemians, and dying children stripped of glamour, pretense, and false shame. Likewise, his painting style outdid Krohg's in its broadness, suppression of detail, and concentration on light effects. Contemporary Norwegian critics disliked these developments and said so, repeatedly.

So controversial and important were the figure paintings of the late 1880s that Munch's work in landscape from the same period has been largely ignored. Beginning in 1883 he spent at least one month a year painting out-of-doors in the Norwegian countryside: with Fritz Thaulow at Modum in 1883 and 1884, with Hans Heyerdahl in Borre and Åsgårdstrand in 1885; at Hisøya near Arendal in the summer of 1886, and at Veierland in the summer of 1887. In Christiania he exhibited his best-known early attempt at a mood landscape (fig. 7) under the title *Evening Mood*.[8] Its dependence on the Fleskum innovations in lighting and coloring is obvious; so too is its use of a device borrowed from Krohg—a wall plunging diagonally into the distance to create a sense of space and depth. In this painting Munch radicalized the Fleskum style as he had Krohg's naturalism. His brushstrokes are bigger and freer, the foreground vegetation is sketchily delineated, and meditative detachment has given way to a sense of painterly energy and involvement.

By 1887 Munch was facing an artistic dilemma. *The Sick Child*, his most innovative and interesting work to date, had found no acceptance outside his immediate circle; his more conventional paintings failed to satisfy his own desire to create something original, moving, and personal. His love affair with Milly Thaulow was decaying.

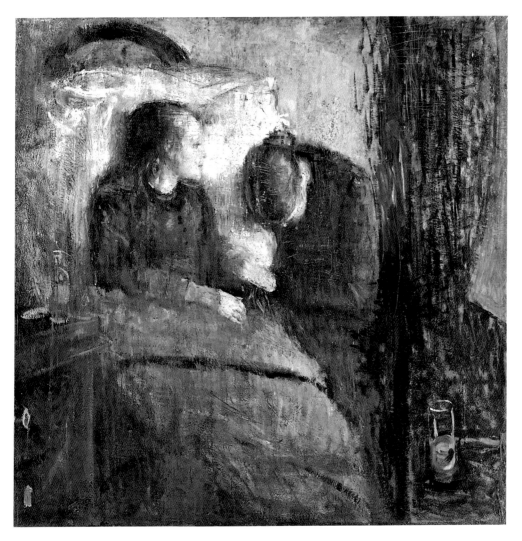

Figure 6. EDVARD MUNCH. *The Sick Child*, 1885–1886. Oil on canvas, 119.5×118.5 cm (47 × 46⅝ in.). Oslo, Nasjonalgalleriet 839.

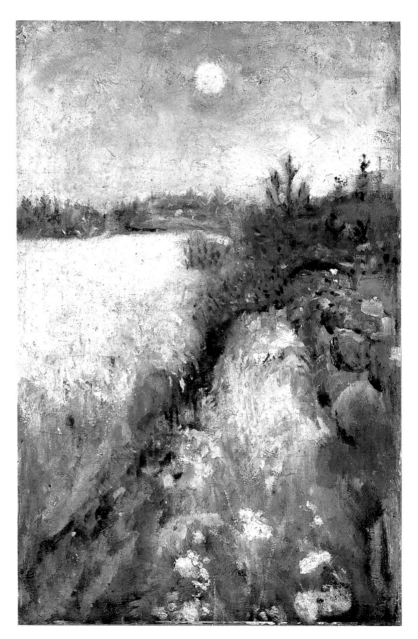

Figure 7. EDVARD MUNCH. *Flowering Meadow in Veierland (Evening Mood)*, 1887. Oil on paper, 66.5 × 44 cm (26 3/16 × 17 5/16 in.). Oslo, Nasjonalgalleriet 1235b.

His friends and teachers supported a plan he made to travel, recommending him for an unprecedented number of grants and scholarships. These enabled Munch to spend most of his time between October 1889 and March 1891 in Paris and to experience directly its art, literature, theater, and culture. Like many Norwegians before him, he had enrolled in Léon Bonnat's academy to study drawing. This relatively conservative decision may have been recommended by Munch's Norwegian mentors, who felt that his draughtsmanship needed tightening and discipline.

Although he associated primarily with Scandinavians while in Paris, Munch attended the Salons and other exhibitions and visited the dealers Goupil, Durand-Ruel, and Theo van Gogh. Thus he had opportunities to see the work of Whistler, the Impressionists, the Postimpressionists including Gauguin, van Gogh, and Lautrec, and the Symbolists Puvis de Chavannes and Klinger. However, his understanding of their paintings continued to follow the contemporary Scandinavian interpretations of naturalism and impressionism. Munch's response to the Continental avant-garde can be inferred from his paintings and drawings of the late '80s and early '90s, which indeed reflect a variety of influences. Judging from the predominance of such pictures in his oeuvre, Munch was especially impressed by French landscape, specifically the cityscape, which the Impressionist painters had made their own. Like Pissarro and Caillebotte he was learning to look at photographs for insights concerning the representation of space, light, and motion.[9] While studying Pissarro, Munch also looked at the very different work of Whistler, who had been admired by the Fleskum school.

In 1890 Munch painted the view of Paris from his window in Saint-Cloud numerous times, alternately imitating Pissarro's and Whistler's very different styles.[10] Whistler's nocturnes, such as *Nocturne: Blue and Silver—Bognor* (fig. 8), displayed in Paris in 1890, seem especially to have influenced Munch's night scenes.[11] Whistler sought above all to create abstract harmonies of color and form. In his smaller works, especially the nocturnes, these are rigorously simplified; at the same time, brushwork has been loosened and paint thinned to create effects of transparency, luminosity, and atmosphere. Whistler's nocturnes are suggestive rather than descriptive; they communicate mood rather than fact.

Comparing Peterssen's *Summer Night* (fig. 5), or even Munch's *Flowering*

23

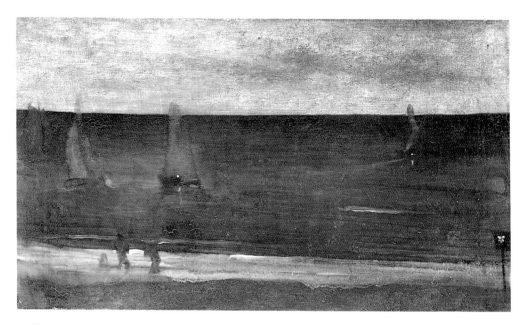

Figure 8. JAMES ABBOTT MACNEILL WHISTLER (American, 1834–1903). *Nocturne: Blue and Silver—Bognor*, 1871–1876. Oil on canvas, 50.3×82.6 cm (19$\frac{13}{16}$×33$\frac{15}{16}$ in.). Washington, D.C., Smithsonian Institution, Freer Gallery of Art.

Meadow in Veierland (fig. 7), with his pastel *Banks of the Seine at Night* (fig. 9), one sees the radical effects of the latter's study of Whistler. In *Banks of the Seine*, river and sky merge into a single sheet of deep blue, linked by twin gaslights and their twin reflections. Trees and figures have been reduced to simple silhouettes, circumstantial detail has been avoided, and the smudged, blurry strokes of pastel are remarkably free and nervous. Subject matter is so incidental to the impact of the composition that it was only recently recognized as a view from the window of Munch's room at Saint-Cloud.[12] This view represents an essential step in his development as a landscape painter, since it shows above all that he had grasped the importance of color and abstraction for the conveyance of mood. In his search for human empathy rather than communion with nature, he broke with the Fleskum school. Simultaneously, his unscientific, almost symbolic use of color became distinctly non-impressionist. Hallmarks of Munch's ma-

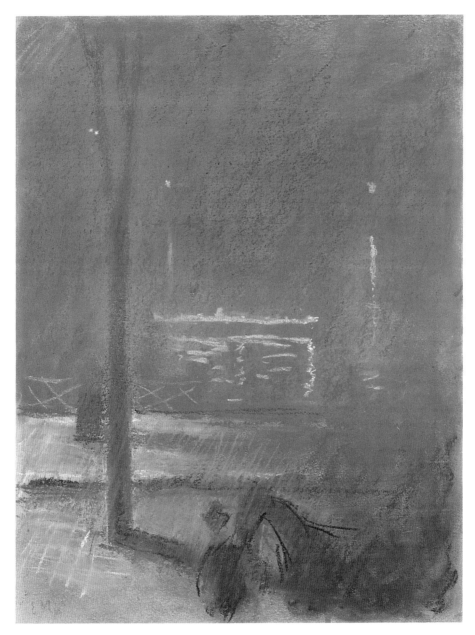

Figure 9. EDVARD MUNCH. *Banks of the Seine at Night*, circa 1890. Pastel on cardboard, 34.9×26.9 cm (13¾×10⅝ in.). Kunstmuseum Bern A 9546.

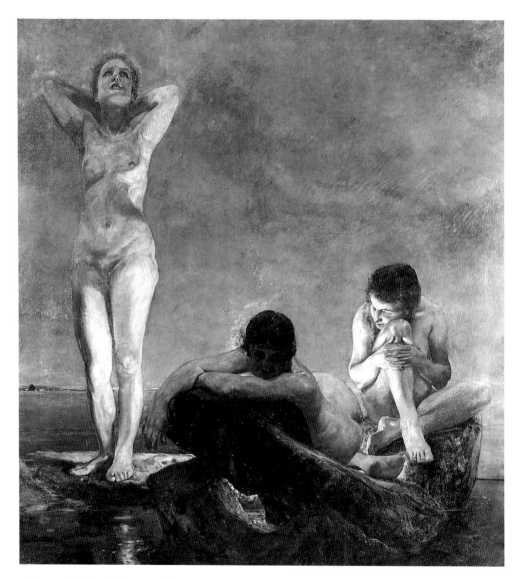

Figure 10. MAX KLINGER (German, 1857–1920). *The Blue Hour*, 1889–1890. Oil on canvas, 191.5×176 cm (75×69⁵⁄₁₆ in.). Leipzig, Museum der Bildenden Künste I.833.

ture style—the dot and streak of a reflected light, for example—appear here for the first time, as does his love of the color blue as a means of suggesting feelings of lone-liness, longing, and mystery.

Whistler's influence extended to other painters of the emerging Symbolist movement, notably Arnold Böcklin and Max Klinger. A friend of Krohg, Klinger was at work in Paris in 1890 on a major picture very much influenced by Whistler's nocturnes (fig. 10). He described it as a study in warm and cool tones, as it set three nude figures lit by firelight against a background of sea, sky, and shadow painted in tones of blue.[13] Although the picture is entitled *The Blue Hour*, Klinger had in fact departed from the meditative romanticism of the Scandinavians as well as from Whistler's aesthetic detachment, redirecting the by-now-familiar mood landscape into the realm of Symbolism.

The "blue hour" was a distinctly fin-de-siècle concept rooted in early Romantic literature. At first associated with the long summer evenings typical of Scandinavia, the term came to designate a misty blue twilight anywhere. In the 1870s and '80s it loosely suggested the twilight of a summer day and its attendant occupation, an after-dinner stroll in a peaceful spot, sometimes near water. Mood landscapes such as the Skagen paintings of P. S. Krøyer or John Singer Sargent's *Luxembourg Gardens at Twilight* (fig. 11) capture the hour's quiet sociability by including promenading couples enjoying their leisure. Even van Gogh's *Starry Night* compositions contain such promenading couples: a man and woman in *The Evening Walk* (1889; São Paulo, Museu de Arte) and *Starry Night over the Rhône River* (1888; private collection), and two laborers in *Road with Cypresses under a Starry Sky* (fig. 12), all paintings Munch might have seen at Theo van Gogh's in Paris. Whistler's nocturnes contain small, contemplative figures, and Munch included a silhouetted man and woman in *Banks of the Seine at Night*. For the solitary *promeneur* or observer, the blue hour could bring feelings of alienation and pessimism. Its mood is hauntingly evoked by Stéphane Mallarmé, a poet whom Munch admired, in "L'azur," a poem that chronicles the changes in the evening sky as it fills with blue haze, turning gray and black while the poet's soul fills with ennui and the desire for death.[14] Change in color evokes change in mood. Klinger's monumental dreamy nudes lost in the contemplation of the elements and the

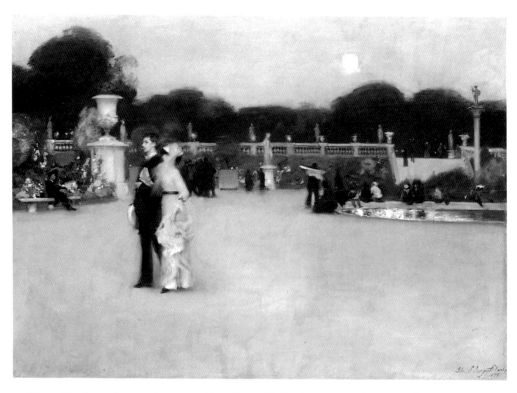

Figure 11. John Singer Sargent (American, 1856–1925). *Luxembourg Gardens at Twilight*, circa 1879. Oil on canvas, 62.9×90.2 cm (24¾×35½ in.). Philadelphia, John G. Johnson Collection J.C. 1080.

infinite represent the hour of isolation, meditation, dream, and ennui described in Symbolist poetry. Thus the Symbolist poets and painters transformed the mood landscape into a subjective portrayal of feeling. Similar associations of blue twilight, dreams, melancholy, and death occur in the poetry of Maurice Maeterlinck and Pierre Loüys.[15]

Munch's engagement with symbolism deepened during his time in Paris since he was living with the Danish Symbolist poet Emanuel Goldstein. Theirs was an intense friendship that rapidly turned into collaboration on plans for an ambitious artistic and literary journal that were never realized. Goldstein encouraged Munch not only to read Symbolist poetry—including his own work *Mandragora: Psychological*

28

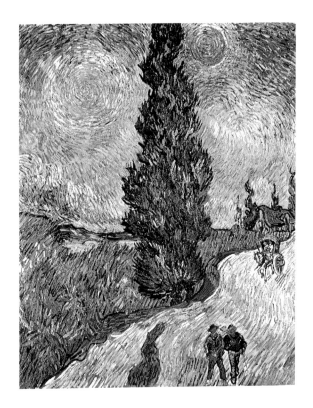

Figure 12. VINCENT VAN GOGH (Dutch, 1853–1890). *Road with Cypresses under a Starry Sky*, 1890. Oil on canvas, 92 × 73 cm (36¼ × 28¾ in.). Otterlo, Rijksmuseum Kröller-Müller 312–12.

Poems, first published in 1886[16]—but also to write himself (a notion that had already been planted in Munch's mind by the Christiania bohemians' love of fictionalized autobiography), and to illustrate the writings of others. Since both men at this time were suffering from unhappy love affairs (Milly Thaulow had broken with her husband and moved in with another lover), the prime Symbolist subjects of women, love, and unhappiness attracted them. Munch seems to have found the Symbolists' goal of expressing personal mood in psychologically or symbolically resonant terms to be a more satisfactory artistic strategy than the nationalist/bohemian commitment to activism from which he had hoped to escape when he left Norway. Consequently, in the most famous of his prose poems, this one written in 1890, he describes his abandonment of naturalism, objective description, and socially oriented subjects, and his desire to

Figure 13. EDVARD MUNCH. *Night in Saint-Cloud*, 1890. Oil on canvas, 64.5 × 54 cm (25⅜ × 21¼ in.). Oslo, Nasjonalgalleriet 1111.

paint instead themes that were timeless, personal, and in some manner sacred. He would paint psychological realities:

> I felt I should make something—I thought it would be so easy—it would take form under my hands like magic.
>
> Then people would see!
>
> A strong naked arm—a tanned powerful neck—a young woman rests her head on the arching chest.
>
> She closes her eyes and listens with open and quivering lips to the words he whispers into her long flowing hair.
>
> I would like to give it form as I now saw it, but in the blue haze.
>
> These two in that moment when they are not themselves, but only one of the thousands of sexual links tying one generation to another generation.
>
> People should understand the sanctity, the grandeur of it, and would take off their hats as if in a church.
>
> I would make a number of such paintings.
>
> No longer would interiors, people who read and women who knit, be painted.
>
> There should be living people who breathe and feel, suffer and love.[17]

In trying to paint "such paintings," Munch built upon Symbolist mood landscapes such as Klinger's *Blue Hour*. The German artist's juxtaposition of figures and landscape suggested correspondences between them, in particular between the psychological states of the characters and the mood projected by their setting. Symbolist poets drew correspondences between the narrator/poet's emotional state and the subject being described. Such correspondences also appear in the first important painting Munch produced in his new manner: *Night in Saint-Cloud* (fig. 13). This composition incorporates the view from Munch's Saint-Cloud window, which he had drawn before in his Whistlerian mood landscape *Banks of the Seine at Night* (fig. 9). However, now it is enframed by the window, the silhouette of the seated figure, and the shadowy darkness of the room. The thoughtful, possibly dejected posture of the sitter echoes the subdued, melancholy feeling of the earlier pastel. The sense of separation from the distant warmth and light of gathered humanity across the river—implicit in the pastel—is reinforced by the landscape's new "frame." *Night in Saint-Cloud* captures

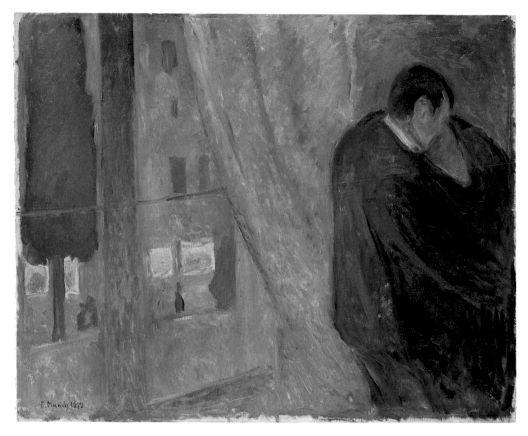

Figure 14. Edvard Munch. *The Kiss*, 1892. Oil on canvas, 73×92 cm (28¾×36¼ in.). Oslo, Nasjonalgalleriet 2812.

Munch's constant feeling of isolation and alienation, the result of being a penniless Norwegian in Paris, of being an artist rejected by his native audience, of being a lover passed over by his beloved, and, finally, of being the rebellious but grieving son of a father who had just died. Even though Emanuel Goldstein may have posed for the shadowy figure at the window, the painting is the first of Munch's many psychological self-portraits.

Once he had discovered this framing device, Munch used it over and over again, heavily during the 1890s and at scattered intervals throughout his career. For

example he employed it in 1891 and 1892, notably in versions of *The Kiss* (see fig. 14) whose windows frame a view Munch had painted around 1891 as the independent composition *Cypress in Moonlight* (location unknown).[18] As if the juxtaposition of meditating figure and mood landscape were not enough, in *The Kiss* Munch enveloped them in a unifying blue haze. The haze enhances mood, but it also blurs outline and obscures detail, suggesting the vagueness of remembered events. In these blue, framed paintings, Munch reformulated his past with a subjective uncertainty completely at odds with the detailed, aggressively confident images of Norwegian naturalism. In Munch's deliberately awkward terms: "I would like to give it form as I now saw it, but in the blue haze."

Munch's symbolist devices, the framed view from the window and the almost monochromatic palette, were not new in nineteenth-century Northern painting. Both had been used by the great German Romantic artist Caspar David Friedrich more than seventy years earlier (fig. 15). The Norwegian critic Andreas Aubert was one of the first to rediscover Friedrich's work as a result of his researches on the Norwegian Romantic painter J. C. Dahl, who had been active, like Friedrich, in Dresden.[19] It is not impossible that Aubert had introduced Munch to Friedrich's painting before 1890, and that *Night in Saint-Cloud* (fig. 13) owes some debt to the German artist's Romantic imagery. Aubert classed Friedrich with the recently rediscovered painter Phillip Otto Runge as one of the great painters of emotion and mood, and he felt that both artists had much to teach painters of the fin-de-siècle.[20] Aubert noted that even Friedrich's most austere subjects—such as the nearly monochromatic *Greifswald in Moonlight* (fig. 16), which Aubert bought for the Norwegian national gallery in 1891—could be read symbolically. The critic interpreted the moonlight glimmering behind the spires of the distant church tower as an expression of Friedrich's religious aspirations.[21] In *Night in Saint-Cloud*, Munch transformed Friedrich's distant light from a Romantic symbol of aspiration into a fin-de-siècle image of separation and loneliness.

In his criticism of Munch's work exhibited in Christiania in 1891, Aubert noted *Night in Saint-Cloud*'s relationships to the mood landscape, but recognized it as the expression of a personal, nervous pessimism. In this respect, Aubert believed, Munch could be classed with the leading painters of the international avant-garde—

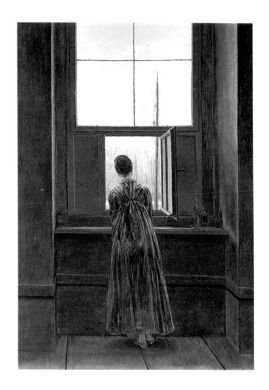

Figure 15. CASPAR DAVID FRIEDRICH (German, 1774–1840). *Woman at the Window*, 1822. Oil on canvas, 44×47 cm (17⅞×18½ in.). Berlin, Staatliche Museen Preussischer Kulturbesitz.

Whistler, Puvis de Chavannes, Klinger, and Böcklin—rather than with the Norwegian naturalists or Continental Impressionists. Aubert understood, as Krohg did not, that Whistler and the others formed a new movement, which Aubert and some of his colleagues labeled "Decadence."[22] To the upholders of "worthy Norwegian worthiness," Aubert's perceptive judgment marked Munch as a dangerous, possibly mad, charlatan.

Fortunately, Munch was not the only suspect genius to inflict disturbing and incomprehensible works of art on the Norwegian bourgeoisie in the 1890s. The writer Knut Hamsun, a few years older than the artist and largely self-educated, published three novels between 1890 and 1894 which, like Munch's paintings of the same years, are credited with laying the foundations for modern art and the modern sensibility. Hamsun's three novels were *Hunger* (1890), *Mysteries* (1892), and *Pan* (1894), all set in Norway. Munch's friends knew Hamsun before the publication of *Hunger*—Weren-

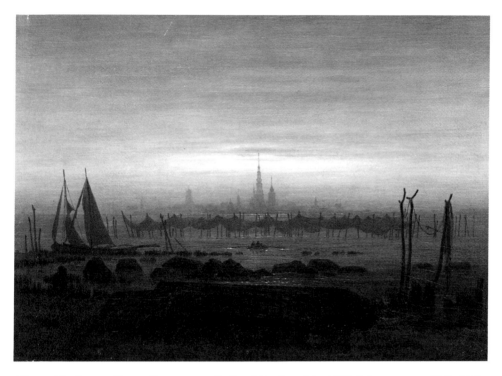

Figure 16. CASPAR DAVID FRIEDRICH. *Greifswald in Moonlight*, 1817. Oil on canvas, 22.5×30.5 cm (8⅞×12 in.). Oslo, Nasjonalgalleriet 387.

skiold had drawn Hamsun's portrait in December 1889—and Munch knew his works even before they met.[23] *Hunger* is about an ambitious writer's flirtation with starvation in the Norwegian capital; the other two books center on complex and destructive love affairs in small coastal villages, not unlike Munch's affair with Milly Thaulow in Ås-gårdstrand. Hamsun's stories differ from earlier European literature in their concentration on mood and psychology at the expense of plot, suspense, and narrative continuity. The novels are not so much about events as about the state of mind of the narrator observing them, a development analogous to Munch's increasing subjectivity in paintings like *Night in Saint-Cloud*.

Hamsun's artistic sensibility is remarkably close to that which Munch ex-

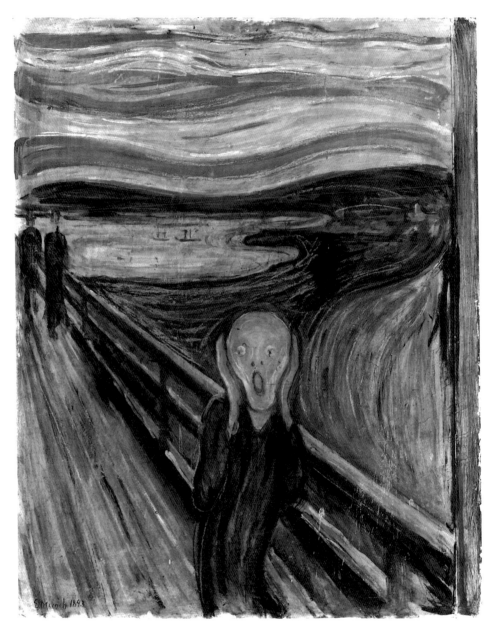

Figure 17. EDVARD MUNCH. *The Scream*, 1893. Tempera and casein on paper, 91×73.5 cm (35 13/16 × 28 15/16 in.). Oslo, Nasjonalgalleriet 939.

pressed in his prose poems and paintings of the early '90s. Hamsun's essay *From the Unconscious Life of the Mind* (1890) describes the mental states Munch was attempting to describe with paint.

> We have an old proverb: There are many things hidden in Nature. For the attentive, searching man of today, fewer and fewer of these secrets remain hidden. One after another they are being brought forth for observation and identification. An increasing number of people who lead mental lives of great intensity, people who are sensitive by nature, notice the steadily more frequent appearance in them of mental states of great strangeness. It might be something completely inexplicable—a wordless and irrational feeling of ecstasy; or a breath of psychic pain; a sense of being spoken to from afar, from the sky, or the sea; an agonisingly developed sense of hearing which can cause one to wince at the murmuring of unseen atoms; an unnatural staring into the heart of some closed kingdom suddenly and briefly revealed; an intuition of some approaching danger in the midst of a carefree hour.[24]

Munch's famous painting *The Scream* (fig. 17) is about that "agonisingly developed sense of hearing" described by Hamsun and which Munch himself experienced one evening sometime in 1890: "I stopped and leaned against the railing, half-dead with fatigue. Over the grey-blue fjord the clouds hung, as red as blood and tongues of flame. My friends drew away. Alone and trembling with fear I experienced nature's great scream."[25] The mental state Hamsun refers to, "an intuition of some approaching danger in the midst of a carefree hour," is the mood that Munch portrayed in *Starry Night* and in his prose poem recounting his conversation with Milly Thaulow at the Grand Hotel in Åsgårdstrand. Deeply moved by the view from the hotel's window, she confesses, "On evenings like this I could do anything—something terribly wrong," and Munch experiences "a premonition that something [is] going to happen."

Hamsun describes similar premonitions of danger in a dialogue between the hero of *Mysteries*, Nagel, and his unattainable beloved, the aristocratic Dagny Kielland. They are walking in the woods above the village at night.

> And now the stillness and beauty of the night had filled him with such elation, such impassioned feeling, that his breathing became short and his eyes misty. Ah, what loveliness

there was in these light nights! He said, raising his voice: "Just look at the hills over there, how clear they are! I am so happy, Fröken, you must bear with me if you don't mind, but to-night I could do silly things from sheer happiness. Do you see these firs and rocks and tussocks and juniper clumps? They look like seated figures in this light. And the night is cool and clean; it doesn't oppress one with queer forebodings and there are no secret dangers lurking anywhere, are there? Now you mustn't take a dislike to me, you really mustn't. It's just as though angels were passing through my soul, singing a hymn. Am I frightening you?"[26]

Everything in Hamsun's passage, from the ambivalent lovers to the exhilarating nocturnal landscape to their emotional responses, is strangely similar to the prose poem Munch wrote at about the same time.

Not surprisingly, the Norwegian critics disliked Hamsun just as much as they disliked Munch, and for the same reasons. The reviewer of Munch's 1892 joint exhibition with the Danish painter J. F. Willumsen in Christiania compared Munch directly with Hamsun, who had just then published *Mysteries*: "One can no longer speak here of Nature, only of twisted imaginations, atmospheres swimming in delirium, sick and feverish hallucinations."[27]

Like one of Hamsun's wandering heroes, Munch rented a tiny cottage and even tinier studio on the edge of Åsgårdstrand in 1889. He intended to use the town as the subject of summertime painting in Norway, as his personal Fleskum. At Åsgårdstrand, where he appears to have begun his affair with Milly Thaulow four years earlier, he could live within one of his own mood landscapes, especially at night: "Have you ever walked along the shoreline and listened to the sea? Have you ever noticed how the evening light dissolves into night? I know of no place on earth that has such beautiful lingering twilight," he told a friend many years later.[28] By 1890 the town had been discovered by other artists, serving for example as an important inspiration for Munch's friend Christian Skredsvig and the naturalist painter Hans Heyerdahl.[29] Christian and Oda Krohg were there in 1889 and 1891, forming with Munch and Heyerdahl the nucleus of a bohemian artists' community. As he continued his peripatetic life on the Continent, Munch increasingly saw Åsgårdstrand as his true home, as the place in the world where he felt most comfortable, even as his lucky place.[30] A friend who knew

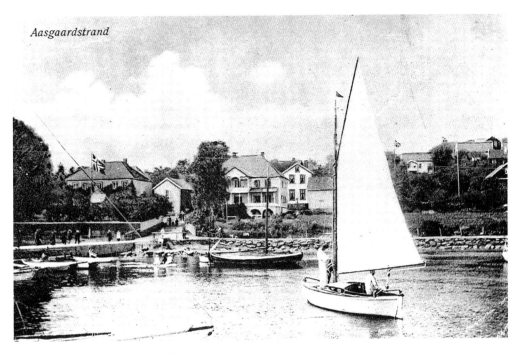

Aasgaardstrand

Figure 18. Postcard view of Åsgårdstrand. Oslo Kommunes Kunstsamlinger B 2352 (F).

him there recalled that he named the path between Borre and Åsgårdstrand Fairytale Walk as if it were a magical route to momentous events.[31]

Åsgårdstrand's name suggests its isolated and special character—*ås* meaning ridge, *gård* meaning court or enclosure, *strand* meaning beach or shore[32]—and accurately describes the town's geography set on and below a ridge running along the coastline. Despite its location on Åsgårdstrand's periphery, Munch's cottage was only a five-minute walk from the center of town, the relatively imposing Grand Hotel overlooking the pier and harbor where Munch kept a small sailboat (fig. 18). One could reach the Grand Hotel from Munch's house by two possible routes. The simplest was a footpath leading down the hill from the house to the shore; after a right turn and a walk of approximately 275 yards one came to the beach in front of the hotel. Or one could follow the street (now named for the painter) above the house to Havnegatan, which

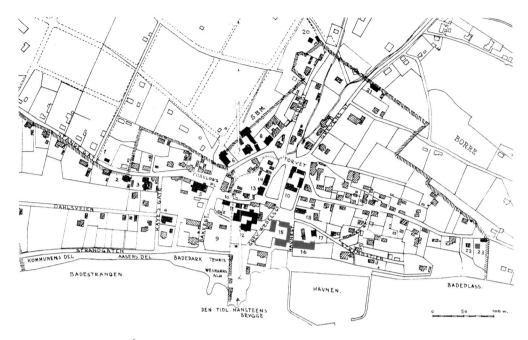

Figure 19. Map of Åsgårdstrand. Number 15 is the Kiøsterudgården, 16 is the Grand Hotel, and 23 is Munch's house. Reproduced from A. Eide, *Åsgårdstrand* (Bergen, 1946), Appendix.

runs down the hill to the harbor, leaving the Grand Hotel on the left (fig. 19).

Munch's growing affection for Åsgårdstrand and its special emotional associations were soon reflected in his painting. While views from 1889 and 1890 recall Fleskum mood landscapes in atmosphere and handling, they soon gave way to extremely personal compositions that set intimate human events against the local coastline. *Jealousy* (fig. 20) represents another bohemian love triangle consisting of Oda Krohg, her husband, and Munch's friend Jappe Nilssen. Nilssen's profile in the foreground of the landscape functions like the silhouetted figure in *Night in Saint-Cloud* (fig. 13). It frames the landscape and suggests the mood the artist wished to convey. In this and other Åsgårdstrand paintings, notably *The Lonely Ones* (1891; destroyed), *The Mysticism of a Night* (1892; private collection), and other compositions related to *Jealousy*, Munch began to paint visual equivalents of Hamsun's novels. And, by cen-

40

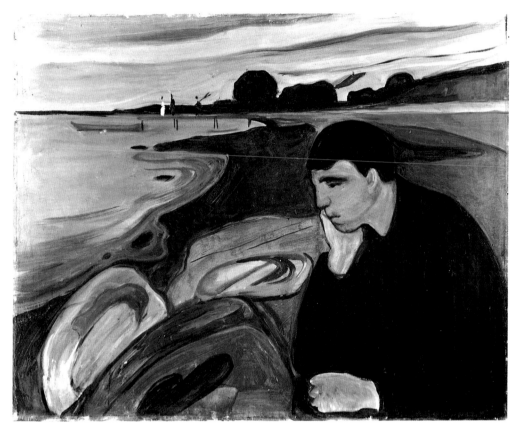

Figure 20. EDVARD MUNCH. *Jealousy*, 1890. Oil on canvas, 66.8 × 100 cm (26⁵⁄₁₆ x 39⅜ in.). Bergen, Rasmus Meyers Samlinger.

tering his life around the site of his affair with Milly Thaulow, he ensured that it would remain a strong but ever-changing memory.

In the 1890s Munch summered in Åsgårdstrand but wintered in Berlin, where he frequented the company of writers and artists whose life-styles, imaginations, and hallucinations were fitting complements to his own. The crowd that gathered at the café Zum Schwarzen Ferkel in 1890–1892 centered around the bizarre figure of Stanislaw Przybyszewski—former medical student, would-be psychologist, satanist, critic, and journalist—and Dagny Juel, a Norwegian beauty who was involved with Munch

and with the playwright August Strindberg before she married Przybyszewski in 1893. Christian Krohg and Andreas Aubert were also there for a time along with a floating population drawn from the Scandinavian and German avant-garde passing through Berlin. In this group of strong, self-destructive personalities, Strindberg was, in the long run, the most important influence on Munch. Like Krohg and Munch he combined strong talents for art and writing, and like Munch and Knut Hamsun he strongly advocated subjectivism in art and literature. Strindberg's tormented experiences with free and married love would not have appeared in the least unusual to the crowd at the Schwarzen Ferkel.

In Berlin Strindberg wrote little but renewed his interest in the visual arts, experimenting with photography and painting in his constant search for self-expression. As part of his investigation into the ways a photographic plate or negative could "see" (and "remember") the visible world, he experimented with unusual cameras and developing processes and with double and long-term exposures.[33] Munch was particularly interested in Strindberg's numerous photographic self-portraits and long exposures of the night sky—"celestographs"—taken with one of his special cameras. The celestographs (see fig. 21) portray the night sky as a smoky, modulated expanse comparable to the "blue haze" of memory in Munch's paintings. The stars in Strindberg's sky are either blurred by atmosphere, distance, and time, or ringed. Thus the camera's distorted memory of the appearance of the sky is analogous to the artist's memory—hazy and distorted—of things seen. The celestographs showed how an indistinct, subjective memory of the infinitude of night might be painted, a solution Munch adopted in *Starry Night* (fig. 22).[34]

Strindberg was not a professional painter, nor had he received much formal training. His paintings usually represent seascapes reminiscent of the views in the Swedish archipelago where he loved to summer (see figs. 23, 24). Their purpose was not so much representational, or evocative (like a mood landscape), as expressionist. Strindberg attacked his canvases with brushes, palette knives, and paint, often beginning without a preconceived design or intention, which would emerge in the course of execution as the paint itself suggested images, moods, or emotions to him. His scraped, worked, encrusted surfaces have something in common with the rough sur-

Figure 21. August Strindberg (Swedish, 1849–1912). *Starry Sky*, 1893–1894. Celestograph. Stockholm, Kungliga Biblioteket 20.

Figure 22. Edvard Munch. *Starry Night*, detail of top left and center.

Figure 23. AUGUST STRINDBERG. *Stormy Sea: Broom Buoy*, 1892. Oil on cardboard, 31 × 19.5 cm (12 3/16 × 7 11/16 in.). Stockholm, Nationalmuseum 6175.

Figure 24. AUGUST STRINDBERG. *Stormy Sea: Buoy with No Top Mark*, 1892. Oil on cardboard, 31 × 20 cm (12 3/16 × 7 7/8 in.). Stockholm, Nationalmuseum 6174.

face of Munch's *Sick Child* (fig. 6). From Strindberg Munch learned about painting as an act of introspection and discovery, of spontaneous creativity. It was a lesson that counteracted his years of training in the canons of naturalism, the aestheticism of Whistler, and the disciplined techniques of French Impressionism. It showed Munch that technique and execution, as well as coloring and form, could express the emotional state of the artist. The action of his hand over the surface of the canvas could become an integral part of the act of memory, which was central to his creative process.

In Strindberg's paintings, the impasted layers of pigment record every movement of his hand. In paintings like *Starry Night*, Munch achieved the same type of record by the opposite means: thinning his paints until he could draw them across the canvas in great washes, like watercolor. He defined masses with contour lines drawn in denser paint. The contours are discontinuous, however, as in *Starry Night*'s shoreline, or multiple, as around the mass of linden trees. Again, like a Strindberg painting or photograph, *Starry Night* records shifting impressions of the image in the painter's memory or imagination.

Meaning: Symbolism,
The Frieze, and The Mirror

STARRY NIGHT, IN ADDITION TO EVOKING A POWERFUL MEMORY, represents a specific landscape: the view one still can see across the Oslofjord from the Havnegatan side of the Grand Hotel in Åsgårdstrand. The road itself, still unpaved in 1893, can barely be seen running across the foreground of the painting and ending at the pier, the beginning of which is not shown. Across Havnegatan and overlooking the fjord stood the town's largest private house, Kiøsterudgården (fig. 25), named for its owners, the Kiøsterud family of Drammen (it still stands today).[35] In the 1890s the head of the family, Abraham Kiøsterud, was a wealthy merchant.[36] Then, as now, the large white house was surrounded on three sides by a white picket fence about four feet high set on a low stone wall. The fence encloses a capacious garden and orchard; the latter seems to have been as carefully trimmed and maintained in the 1890s as it is today. The view to the fjord from the house over the treetops is still magnificent. In the far corner of the garden, near the beach, stand three enormous linden trees. Their trunks grow within a few feet of each other, and in summer their dense foliage appears to belong to a single tree. There is another large house across the street, Grev Wedelsgatan.

The view depicted in *Starry Night* looks down from the Grand Hotel window and across this enclosed private garden. The great linden trees form a mound silhouetted against the night sky, and their bulky shape is pierced by a dot and streak of light from the moon hidden behind them. Åsgårdstrand's topography does not explain *Starry Night*'s most enigmatic element, however: the small red house standing near the great lindens, to the right of the streak of moonlight. No such building seems ever to have existed at the foot of the Kiøsterudgården or anywhere in its immediate vicinity. Nor is it clear in the painting exactly where the house is situated. Is it in front of the trees, or does one glimpse it through the foliage?

In *Starry Night* Munch represented the summer night sky accurately, thanks

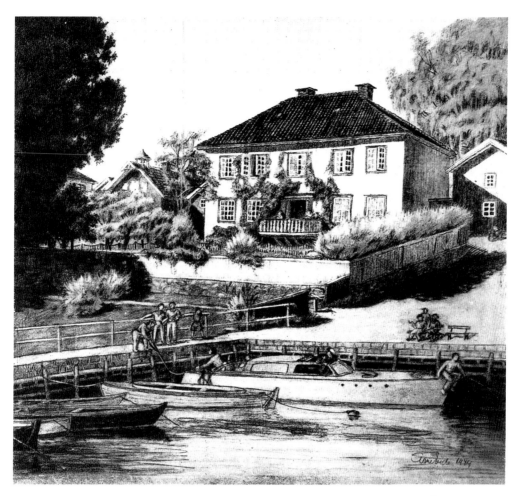

Figure 25. *Kiøsterudgården Seen from the Pier*, 1939(?). Reproduced from A. Eide, *Åsgårdstrand* (Bergen, 1946), p. 55.

in part to Strindberg's celestographs. In Norway in high summer the sun barely sets at all, and the reddish glow of sunset never fades, merging gradually into sunrise. The pink "star" on the horizon in *Starry Night* is actually the planet Venus; the two prominent stars on the left casting their streaky reflections on the water may belong to the constellation Aries.[37] These heavenly bodies move around the night sky according to an eight-year cycle and can thus be used to measure time. Their position in *Starry Night* is a subtle reference to Munch's love affair with Milly Thaulow, which had begun eight years before, when the "stars" had last been in the same position.[38] This allusion lifts *Starry Night* out of the category of mood landscape in which it originated. Clearly, the painting is about more than a pleasant evening at a seaside resort. Earlier titles Munch had given it, *Mysticism of a Summer Night* (1894) and *Mysticism* (1895), reinforced its symbolist character and may have alluded to Hamsun's novel *Mysteries*. In fact, by pairing human and natural forms, the composition describes a mystical correspondence between events in human life and events in nature like that described by Hamsun in his 1890 essay on the unconscious.

A second reference to lovers is found in the moundlike blue shadow on the fence echoing the form of the merged linden trees. The shadow runs all the way to the lower edge of the composition; the inference is that it is the shadow of a person (or persons) looking down from the window of the Grand Hotel and backlit by the illuminated interior. The form of the shadow is also reminiscent of the merged lovers in Munch's *Kiss* (fig. 14). The latter's early versions from 1892, colored by the "blue haze" of memory and regret, show lovers standing before a window with a view out onto a night landscape. In *Starry Night*, the window framing the view has been reduced to show only the figures' shadow instead of an inhabited interior.

Munch's equation of merging trees and lovers recalls the Greek myth of Philemon and Baucis, a couple transformed into two trees so that they need never part. The paired stars above the horizon strengthen Munch's symbolism of two people linked by the forces of nature and destiny; the dot and streak of moonlight hang above their joint shadow like a benediction.[39] According to Munch, "People's souls are like planets. Like a star that appears out of the gloom and meets another star—they shine brightly and then disappear completely into the darkness. It is the same when a man

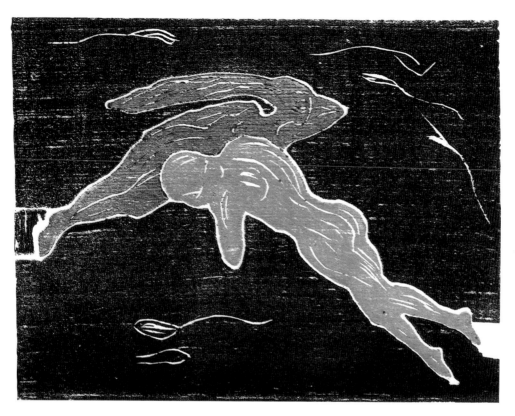

Figure 26. EDVARD MUNCH. *Encounter in Space*, 1899. Woodcut, 18.1 × 25.1 cm (7⅛ × 9⅞ in.). Oslo Kommunes Kunstsamlinger G/t 603.

and woman meet—they glide towards each other, the spark of love ignites and flares up, then they vanish, both going their own separate ways. Only a few come together in a flame that is large enough to become one."[40] *Starry Night* may therefore represent Munch's recollection of two stages in his love affair with Milly Thaulow: the first encounter (see fig. 26) and the blazing moment of union. The appearance of Venus, predicting the arrival of the dawn and evoking the goddess of love, promises literally and metaphorically the beginning of love. Thus the symbolism of the picture, personal and discrete, contributes to the excited, wary mood suggested by its formal qualities and manner of execution.

 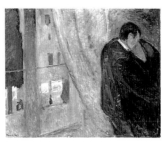 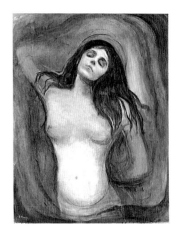

Figure 27a. EDVARD MUNCH. *The Voice*, 1893. Oil on canvas, 87.6×107.9 cm (34½× 42½ in.). Boston, Museum of Fine Arts, Ernest Wadsworth Longfellow Fund 59.301.

Figure 27b. EDVARD MUNCH. *The Kiss*, 1892 (see fig. 14).

Figure 27c. EDVARD MUNCH. *Madonna*, 1894–1895. Oil on canvas, 91×70.5 cm (35¹³/₁₆× 27¾ in.). Oslo, Nasjonalgalleriet 841.

Soon after Munch completed *Starry Night*, he gave it to his teacher and advocate Christian Krohg. He did this because he wanted something in return, *The Sick Child* (fig. 6), which he had given Krohg in 1891 out of gratitude for the latter's stout defense of the controversial painting in the Norwegian press. By 1893, however, Munch had found a buyer for *The Sick Child* and, chronically short of both money and patrons, could not afford to pass up a sale. Sometime between 1893 and 1895 he offered Krohg and his wife, Oda, their choice of his work in exchange, and Oda Krohg chose *Starry Night*.[41] As was the case with the majority of his important paintings, Munch could not bear to part with *Starry Night* permanently even after he had given it to someone else. The Krohgs were generous with their pictures, having allowed Munch to borrow *The Sick Child* repeatedly while they owned it. The fact that they were equally generous with *Starry Night* is suggested by the picture's hectic early exhibition history, during which it spent more time traveling with the artist than decorating the home of

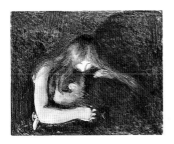 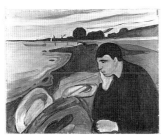 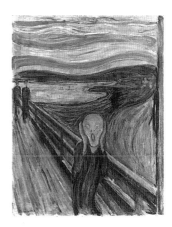

Figure 27d. EDVARD MUNCH. *Vampire*, 1893. Oil on canvas, 80.5 × 100.5 cm (31 11/16 × 39 9/16 in.). Göteborgs Konstmuseum 640.

Figure 27e. EDVARD MUNCH. *Jealousy*, 1890 (see fig. 20).

Figure 27f. EDVARD MUNCH. *The Scream*, 1893 (see fig. 17).

its nominal owners. Despite the fact that the painting was now complete, Munch continued to work with it in exhibitions by incorporating it into groups of his other works which further developed the content and symbolism of the individual canvases.

Starry Night made its public debut at the Berlin gallery Unter den Linden in December 1893. This was Munch's third exhibition in that city; the first, held at the Verein Berliner Künstler in November 1892, had closed after five days due to the scandalized outcry over his work. Munch tried a second time, in December 1892, at the Equitable Palast; this exhibition was notable for the large "pure" Norwegian flag which marked its entrance.[42] The absence of the then-customary emblem signifying Norway's union with Sweden constituted one of Munch's few overt demonstrations of his political sympathies.

The exhibition at Unter den Linden initiated a series of works which would become the major focus of Munch's maturity: The Frieze of Life. Almost casually, he grouped six compositions together under the title Studies for a Series—Love. *The Voice, The Kiss, Madonna, Vampire, Jealousy,* and *The Scream* (figs. 27a–f) had been

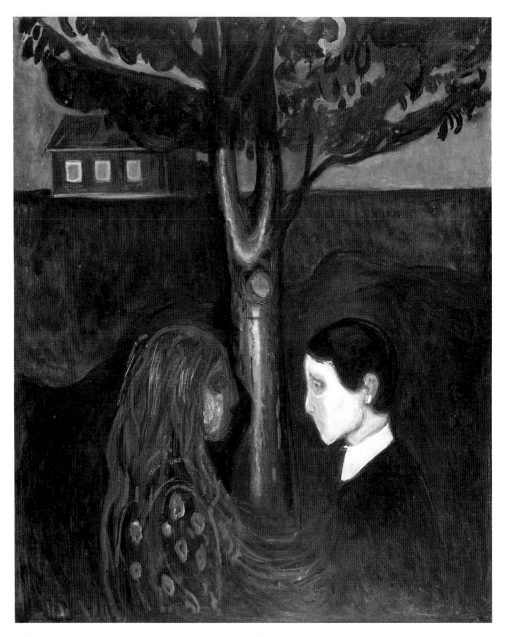

Figure 28. EDVARD MUNCH. *Eye in Eye*, 1894. Oil on canvas, 137 × 110 cm (53 15⁄16 × 43 5⁄16 in.). Oslo Kommunes Kunstsamlinger M 502.

painted at one- or two-year intervals and reflected a multitude of experiences of the artist or his friends. They showed few formal interrelationships beyond their common use of color to portray mood, however, and in this respect they differed significantly from other great decorative suites of the time—Whistler's *Peacock Room* (1877; Washington, D.C., Smithsonian Institution, Freer Gallery of Art), for example. A couple of the versions exhibited together in 1892 were finished oil paintings, but at least three were rough pastel studies. Hung side by side, they loosely portrayed a sort of lover's progress from initial attraction to consummation, jealousy, and despair. From the bits and pieces of bohemian life, enlarged, generalized, and backed by the symbolic power of form, color, and landscape, Munch had created a cycle of paintings expressing his most fundamental view of the human condition. As he put it, "The frieze is intended as a series of decorative pictures, which, gathered together, would give a picture of life. Through them all there winds the curving shoreline, and beyond it the sea, while under the trees, life, with all its complexity of grief and joy, carries on."[43] The importance of shoreline and trees (most of these pictures show Åsgårdstrand) suggests that Munch viewed primitive, wild nature and small Norwegian towns as an appropriate setting for modern life and art. The equation of urbanism and modernity, so fashionable in artistic circles in Paris, had no lasting impact on Munch's personal views.

The Love paintings acquired new meanings according to their groupings. As Munch recalled in 1933, "When they were brought together, suddenly a single musical note went through them and they became completely different from what they had been. A symphony resulted. . . . It was in this manner that I began to paint friezes."[44] For the rest of his life, Munch experimented with the arrangements of paintings eventually known as The Frieze of Life, and those of prints, which he would entitle The Mirror. Although he exhibited *Starry Night* at Unter den Linden alongside the Love series in December 1893, he did not actually include it *in* the series until his October 1894 exhibition at Galerie Blanche in Stockholm. There, appropriately both for its dawn subject and for its powerful evocation of mood, it was the first picture in the series, the overture to Munch's symphony. In these new and deliberate associations with images of love and, later, of death, *Starry Night*'s implicit meaning became explicit and assumed mythic proportions.

In Stockholm in 1894, and six months later in Berlin in March 1895, *Starry Night* was followed by a new painting, *Eye in Eye* (fig. 28); then came *The Voice*, *The Kiss*, and the rest of the core group. Munch may have painted *Eye in Eye* deliberately to bridge the gap between his overture and his symphony, since by 1894 he was manipulating subjects and images within the series deliberately. *Eye in Eye* represents a couple, a red-haired woman and a wan, apprehensive man, facing each other beneath a spreading tree. The house, the woman's hair, and a flowering plant to the man's right are all colored red, for Munch as for many artists the color of life, blood, and sexual passion. The contrast with *Starry Night*'s blueness, evoking romantic yearning, is startling. However, the composition of *Eye in Eye* repeats and explicates *Starry Night*'s theme of lovers beneath a tree, even using the highlighted fork in the tree's trunk to suggest the union of the two people. The red house appears again, set distinctly behind the tree and on the horizon. As in *Starry Night*, an undulating contour (but shadow rather than shoreline) distinguishes foreground from distance and encloses the pair in a distinct space. *Eye in Eye* relates *Starry Night*'s theme of a man and woman, a tree, and an enclosed garden to the standard iconography of Adam and Eve beneath the Tree of Knowledge in the Garden of Eden. The sexual power of the woman, the man's vulnerability to temptation, and perhaps even future human domesticity (i.e., the house) are symbolically described in recognizably biblical terms. In a much later reworking of the *Eye in Eye* theme, executed in 1908, Munch portrayed the woman holding an apple and called the composition *Adam and Eve* (Oslo Kommunes Kunstsamlinger OKK M391).

A significant relationship exists between Munch's Love series and his friend Max Klinger's similarly titled print cycle dated 1887.[45] Klinger's nine etchings relate in Symbolist terms the conventional story of a young woman who falls in love, conceives a child out of wedlock, suffers deep shame, and dies in childbirth. The second and third images of the cycle provide both close comparisons to, and significant contrasts with, Munch's *Starry Night* and *Eye in Eye*. Klinger's *Love: At the Gate* (fig. 29) shares with *Starry Night* the idea of potential lovers meeting at or near the edge of an enclosed, Edenic garden. In Klinger's *Love: In the Park* (fig. 30), as in *Eye in Eye*, the affair has progressed from potential to actual passion as the two lovers meet beneath

Figure 29. MAX KLINGER. *A Love: At the Gate*, 1887. Etching, 40.5×26.5 cm (15¹⁵⁄₁₆×10⁷⁄₁₆ in.). Philadelphia Museum of Art, Gift of the Print Club of Philadelphia.

Figure 30. MAX KLINGER. *A Love: In the Park*, 1887. Etching, 41×24.4 cm (16⅛×9⅝ in.). Berlin, Staatliche Museen, Küpferstichkabinett.

an enormous tree. Both artists clearly were fascinated with the relationship of modern life to the great themes of the Bible and mythology: love, sin, retribution, and death. They dressed their characters in contemporary garments and placed them in modern settings, but drew mythic comparisons in their use of color, form, and imagery. In the latter respect, the differences between Munch's and Klinger's series become apparent. Restricted to a black-and-white format, Klinger relied more on symbolic detail, such as the serpent-dragon in the ironwork of *A Love: At the Gate*, whereas Munch could generalize thanks to the symbolic power of his color. If there can be said to be a serpent

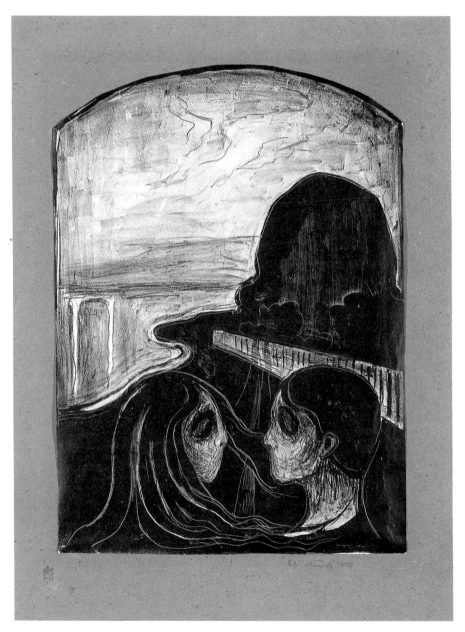

Figure 31. EDVARD MUNCH. *Attraction I*, 1896. Hand-colored lithograph, 40.6×33.6 cm (16×13⅝ in.). Cambridge, Harvard University Art Museums M20224.

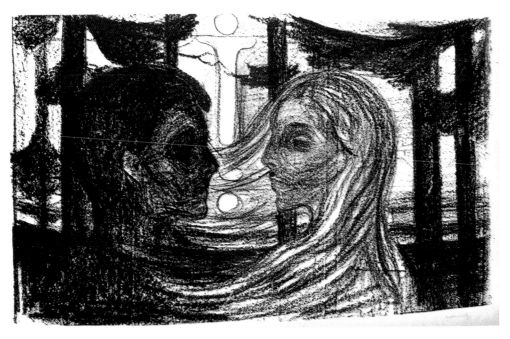

Figure 32. EDVARD MUNCH. *Attraction II*, 1896. Hand-colored lithograph, 39.9×62.1 cm (15¹¹⁄₁₆×24⁷⁄₁₆ in.). Washington, D.C., The Epstein Collections.

at all in *Starry Night*, it is present only subliminally in the contour of the Åsgårdstrand beach, whose shoreline Munch described as "sinuous" and "snake like" in his later writings.⁴⁶ Munch's attitude toward nature, love, sin, and retribution was also considerably more pagan and complex than Klinger's relatively traditional moral viewpoint.

In fact Munch's subsequent development of the Love themes moved gradually away from the biblical overtones of *Eye in Eye*. However, the next major development of the series occurred in graphics, not paintings. Munch began to experiment with printmaking in 1894, moving back to Paris in 1895–1897 to study intensively the techniques of lithography, woodcut, and etching in the French workshops. At this time he must have come into contact with Gauguin's Tahitian paintings and stylized, powerful woodcuts, of which he would have learned through William François Molard, a friend of Gauguin and of many Scandinavian artists. Munch began a print series in

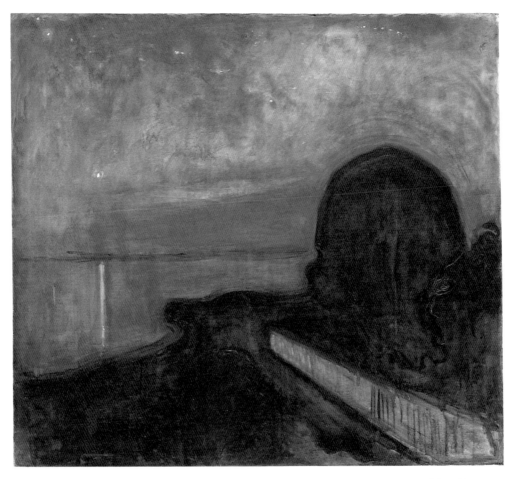

Figure 33. EDVARD MUNCH. *Starry Night*, circa 1895–1897. Oil on canvas, 135×140 cm (53⅛×55⅛ in.). Wuppertal, Von der Heydt-Museum.

1895 and displayed it in the fall of 1897 under the title The Mirror. As with his paintings, he produced multiple versions of each print subject, working in several graphic media and even hand coloring some prints. In its earliest extant form, preserved in a portfolio and known as the KB Series, The Mirror contained twelve images, including the familiar *Kiss*, *Madonna*, and *Vampire* (figs. 27b–d). But the two prints that begin the portfolio, *Attraction I* and *Attraction II* (figs. 31, 32), both hand-colored lithographs, are significant reworkings of the compositions of the three paintings leading off The Frieze of Life: *Starry Night*, *Eye in Eye*, and *The Voice*.[47]

The composition called *Attraction II* (fig. 32) actually appeared first in the KB portfolio. Two lovers stand face to face on the shoreline at Borre, thus combining the setting of *The Voice* with the couple from *Eye in Eye*. In *Attraction I* (fig. 31), lovers stand before the garden depicted in *Starry Night*. Munch has suppressed several details from the painting, however. Venus is gone from the horizon, and the streak of moonlight no longer glimmers through the trees' foliage, nor can the red house be seen. These changes eliminate *Starry Night*'s allusions to the moment of the lovers' embrace.

Similar omissions are found in Munch's second painted rendition of *Starry Night*, which was completed by 1897 (fig. 33). This revision also replaces the shadow on the fence with a reddish shadow in the center foreground that appears to have been cast by a single figure, perhaps the artist himself. The dry, thick paint in the work, along with the boldly drawn, unbroken contours of shoreline and orchard foliage, suggest a date of circa 1895, when similar stylistic changes appeared in Munch's prints and other paintings, perhaps as a result of his interest in Gauguin's work. It would seem that in the course of transforming *Starry Night* into *Attraction I*, Munch also considered transforming it into an image of solitary meditation on the nocturnal landscape, in the vein of his *Night in Saint-Cloud* (fig. 13) and Symbolist poetry. In the print, however, the idea of pairing is emphasized by the parallel shadows cast by the figures and the parallel streaks of starlight reflected on the water. In other versions of the *Attraction I* subject, Munch made the pairing symbolism even more obvious. An etched and aquatint version done in 1895 places the two stars closer together and moves them to the center of the composition between the lovers (fig. 34). Even simpler is a drawing from the same year that encloses the couple's shadows within the silhouette of the

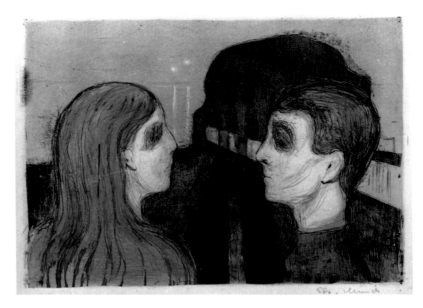

Figure 34. EDVARD MUNCH. *Attraction*, 1895. Etching, aquatint, and drypoint, 21.5×31.3 cm (8 7/16 × 12 5/16 in.). Oslo Kommunes Kunstsamlinger G/r 17-26.

Figure 35. EDVARD MUNCH. *Attraction*, 1895. Charcoal and tusche on paper, 20×48.5 cm (7 7/8 × 19 1/8 in.). Oslo Kommunes Kunstsamlinger T 317.

great tree in order to suggest their union (fig. 35). Moon, stars, fence—indeed any indication of location or physical space—have given way to symbolic abstraction.

Both of the *Attraction* prints in the KB Series and The Mirror replace the house and blazing light with a new symbol of emotional union probably inspired by French Art Nouveau designs. In each the woman's hair blows toward the man, appearing to entangle him as a symbol of their attraction. Munch describes such entanglement in a prose poem appended to one of the prints of *Attraction II*:

> Then we stood facing each
> other and your eyes
> looked into my eyes
> then I felt
> as if invisible
> threads led from
> your eyes into
> my eyes and
> tied our hearts
> together.[48]

All of these changes minimize the biblical connotations of *Eye in Eye* while they enhance the symbolist correspondence between human and natural events. Nevertheless the sense of *Attraction I* as a type of religious image is emphasized by the composition's arched top, reminiscent of an altarpiece. The shape is especially close to Caspar David Friedrich's "Tetschen Altar" (fig. 36), which was conceived in 1808 as a specifically "modern" interpretation of a traditional altarpiece subject.

It is significant that after his various experiments with abstracted landscapes in the *Attraction* prints, Munch finally opted for the most specific view of Åsgårdstrand in the lithograph he exhibited. Much suggests that he felt more than a simple affection for the town, and for the Kiøsterudgården in particular. For one thing, he represented the garden repeatedly in other paintings and prints, as if he were walking around it in his mind's eye. Long after he had moved away from the town, he asked a friend, "Isn't it sad that I've painted everything there is to paint down there? To walk about the village is like walking among my own pictures."[49] There is the famous series of paint-

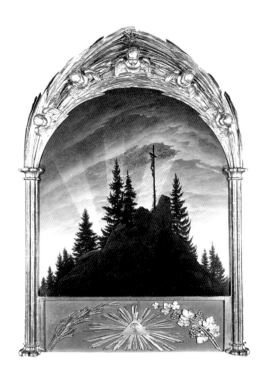

Figure 36. CASPAR DAVID FRIEDRICH. *The Cross in the Mountains* (The "Tetschen Altar"), 1808. Oil on canvas, 115×110 cm (45¼×43⁵⁄₁₆ in.). Staatliche Kunstsammlungen Dresden. Photo: Deutsche Fotothek, Dresden.

ings and prints, known as *Girls on the Pier* (see fig. 37), that look back toward the house, garden, and trees from the end of the pier at the foot of Havnegatan. An imposing composition, *Summer Night in Åsgårdstrand* (fig. 38), looks along the fence and up toward the linden trees from the spot where Havnegatan meets the walkway by the shore. *House under the Trees* (1905; Oslo, Nils Werring) also looks back at Kiøsterudgården from the pier, but shows leafless trees and a nearly empty garden. In the two latter paintings and the print (Schiefler 260) related to *House under the Trees*, the three great lindens are reduced to two, a last reminiscence of the lovers of 1885.

It is easy to compare Åsgårdstrand to an enclosed garden cut off from the outside world, like the even smaller Kiøsterudgården or Eden, the enclosed garden of Genesis, or Midgård, the citadel the Norse gods built for the first humans. Åsgårdstrand, especially as represented in *Starry Night*, resembled in its essentials the primitive world as it was described in the Norse creation myths recorded by Snorri Stur-

Figure 37. EDVARD MUNCH. *Girls on the Pier*, circa 1901. Oil on canvas, 136×125.5 cm (53⁹⁄₁₆×49⁷⁄₁₆ in.). Oslo, Nasjonalgalleriet 844.

Figure 38. EDVARD MUNCH. *Summer Night in Åsgårdstrand*, 1904–1905. Oil on canvas, 99×103.5 cm (39×40¾ in.). Paris, Musée d'Orsay. Photo: Musées Nationaux, Paris.

luson and familiar to every Norwegian from childhood. According to Snorri, the world was formed from the fallen body of the giant Ymir.

Of Ymir's flesh the earth was fashioned,
 And of his sweat the sea;
Crags of his bones, trees of his hair,
 And of his skull the sky.
Then of his brows the blithe gods made
 Midgård for sons of men;
And of his brain the bitter-mooded
 Clouds were all created

Then said Gangleri: "Much indeed they had accomplished then, methinks, when earth and heaven were made, and the sun and constellations of heaven were fixed, and division was made of days; now whence come the men that people the world?" And Hárr answered: "When the sons of Borr were walking along the sea-strand, they found two trees, and took up the trees and shaped men of them: the first gave them spirit and life; the second, wit and feeling; the third, form, speech, hearing, and sight. They gave them clothing and names: the male was called Askr, and the female Embla, and of them was mankind begotten, which received a dwelling-place under Midgård."[50]

Thus the paired trees and lovers of *Starry Night* evoke Askr and Embla as well as Adam and Eve, or Philemon and Baucis, or Munch and Milly Thaulow. The fusion of these myths—biblical, Norse, Hellenic, and modern—within a single image transforms the simple seaside town into the locus of Creation, of human beginnings. At work during Norway's struggle for independence and mindful of his homeland's identity as a modern nation-in-the-making, Munch chose the tiny village of Åsgårdstrand as the setting for a new vision of humanity and a new order.

Continuation: Changing Views of the Heroic North

SOMETIME AFTER 1896, the Krohgs must have experienced a strange sense of déjà vu when Munch asked them to give back *Starry Night* so that he could sell it to another patron. As usual Munch was short of money; this time he hoped to make some by selling a painting to Fridtjof Nansen, the arctic explorer who was already a national hero and—along with Henrik Ibsen and perhaps Munch himself—one of the few Norwegians to enjoy international fame at the turn of the century. The sale occurred between the fall of 1896 and 1902.[51] The association between Nansen and Munch cemented by the sale of the first version of *Starry Night* had curious effects. It gave to *Starry Night* a Norwegian nationalist significance that for a time overpowered its subtler inherent themes, and it transformed Munch into a painter acutely aware of his audience. Nansen's support marked the beginning of Munch's reconciliation with the Norwegian public and his gradual assumption of the role of a great man in his native land. In addition Nansen's ownership of *Starry Night* introduced the theme into a new context, that of the heroic Norwegian winter landscape with which he himself was closely associated.

Fridtjof Nansen was born in 1861, making him two years older than Edvard Munch. Always a talented draughtsman and confirmed outdoorsman, Nansen studied zoology, planning to make use of his natural abilities. Although he considered himself a scientist, he became famous as an explorer after walking across the arctic wasteland of Greenland's ice cap in 1888–1889. On his return from this trip, he went to Åsgårdstrand to sit for the painter Hans Heyerdahl, and it may have been then that he and Munch first met. In 1890 Nansen began to plan another, far more dangerous, expedition, to the North Pole, which no explorer had yet reached. After three years of research and fund-raising (an effort to which the owner of Kiøsterudgården made important contributions[52]), Nansen left Christiania on a specially built boat, the *Fram*,

in June 1893. He was not to return to Norway until August 1896, having endured extraordinary hardship in his efforts to reach the Pole. He trekked to latitude 86°14′, the farthest north any human being had yet journeyed. His two-volume account of the voyage of the *Fram* and his harrowing year camped on the ice of Franz Josef Land brought him international fame.

This account, *Farthest North*, published in 1897,[53] includes long extracts from the diaries Nansen kept on board the *Fram*. His mystical descriptions of the polar landscape and his manifest interest in landscape painting may have encouraged Munch to offer him *Starry Night*. Two passages in particular describe night skies reminiscent of that depicted in Munch's painting:

(Mon Jan 8, 1894) Little Liv [Nansen's daughter] is a year old today; it will be a fête day at home. As I was lying on the sofa reading after dinner, Peter put his head in at the door and asked me to come up and look at a strange star which had just shown itself above the horizon, shining like a beacon flame. I got quite a start when I came on deck and saw a strong red light just above the edge of the ice in the south. It twinkled and changed color; it looked just as if some one were carrying a lantern over the ice; I actually believe that for a moment I so far forgot our surroundings as to think that it really was some person approaching from the south. It was Venus, which we see to-day for the first time, as it has till now been beneath the horizon. It is beautiful with its red light. It must be Liv's star, as Jupiter is the home star. . . .

11 July 1894 Now I am almost longing for the polar night for the everlasting wonderland of the stars with the spectral northern lights, and the moon sailing through the profound silence. It is like a dream, like a glimpse into the realms of fantasy. There are no forms, no cumbrous reality—only a vision woven of silver and violet ether, rising up from earth and floating out into infinity . . . But this eternal day, with its oppressive actuality, interests me no longer—does not entice me out of my lair. Life is one incessant hurrying from one task to another; everything must be done and nothing neglected, day after day, week after week; and the working day is long, seldom ending till far over midnight. But through it all runs the same sensation of longing and emptiness, which must not be noted. Ah, but at times there is no holding it aloof, and the hands sink down without will or strength—so weary, so unutterably weary.

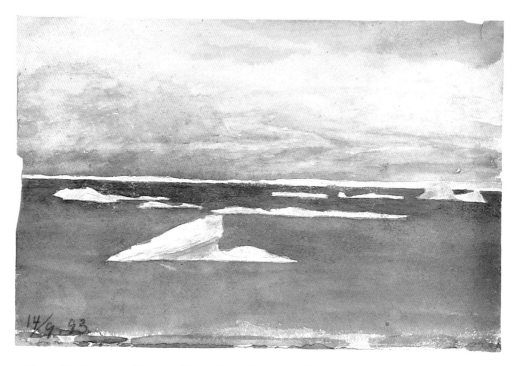

Figure 39. Fridtjof Nansen (Norwegian, 1861–1930). *Evening Mood off Siberia's North Coast,* 1893. Watercolor. Lysaker, private collection.

Ah! life's peace is to be found by holy men in the desert. Here, indeed, there is desert enough; but peace—of that I know nothing. I suppose it is the holiness that is lacking.[54]

Farthest North is filled with such descriptions of landscape, light effects, and author's mood. Nansen observed multicolored haloed stars, the streaming colors of the aurora borealis, and disorienting reflections of light from ice fields and low-hanging clouds, and drew them in watercolor (see fig. 39) and pastel. The surreal simplicity of the arctic landscape inspired works matching Whistler's or Munch's in elegance, restraint, and abstraction. It is easy to see why Nansen would have appreciated the naturalistic effects and powerful yearning mood of Munch's *Starry Night*.

In the absence of testimony from Nansen himself, one cannot be certain exactly how he saw or understood *Starry Night*. On the one hand, it seems unlikely that

he would have cared much for its symbolic content, unless he associated the red star on its horizon with the birth date of his daughter. On the other, there is much circumstantial evidence to suggest that he would have viewed it within the established context of the Scandinavian mood landscape. Since the mid-1880s Nansen had been a good friend of Erik Werenskiold, one of the original Fleskum artists. The explorer had sat for Heyerdahl in 1889 only because he could not afford Werenskiold; however, he did take drawing lessons from the latter, who advised him on his book illustrations and art collecting. Through Werenskiold, Nansen developed friendships with the rest of the Fleskum group.[55] Even so, it is surprising to realize that on the *Fram*, where every object and supply had been carefully selected to maximize storage space, Nansen found room to stow several Norwegian paintings. He refers to these in *Farthest North*:

> (Jan 1, 1894) And Norway, our fatherland, what has the old year brought to thee, and what is the new year bringing? Vain to think of that; but I look at our pictures, the gifts of Werenskjöld, Munthe, Kitty Kielland, Skredsvig, Hansteen, Eilif Peterssen, and I am at home, at home! . . .
>
> (March 27, 1894) I look at Eilif Peterssen's picture, a Norwegian pine forest, and I am there in spirit. How marvellously lovely it is there now, in the spring, in the dim, melancholy stillness that reigns among the stately stems![56]

There is also an entry describing difficulties with Gerhard Munthe's *Three Princesses* (date and location unknown), which repeatedly fell on the sailors' heads until it was securely nailed to the wall above the sofa in the saloon.[57]

Clearly, Nansen would have seen *Starry Night* not only against the background of his arctic experience and his familiarity with the Fleskum school but also in the context of Scandinavian landscape painting of the 1890s. The summer-night mood landscape was already becoming a cliché, albeit a beautiful and popular one. *Starry Night* fitted right in with Harald Sohlberg's *Night Glow* (fig. 40) or the work of Theodore Kittelson, Prins Eugen, Richard Bergh, Eugène Jansson, or Peder Severin Krøyer.[58] Furthermore, all of these glorifications of the Scandinavian landscape and climate appealed to nationalistic sentiments such as Nansen expressed in his diaries.

Nansen's exploits and his patriotic attitude transformed the Norwegian vision

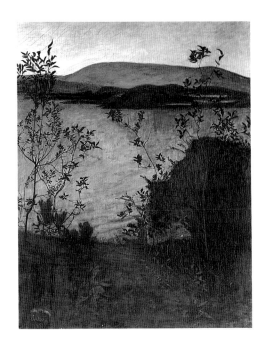

Figure 40. HARALD SOHLBERG (Norwegian, 1869–1935). *Night Glow*, 1893. Oil on canvas, 79.5 × 62 cm (31⁵/₁₆ × 24⁷/₁₆ in.). Oslo, Nasjonalgalleriet 441.

of landscape in paradoxical ways. Up to the end of the nineteenth century, Norwegians, including Munch and Nansen, had loved the landscape for its cool, rich, meditative qualities. It was the summer landscape that was celebrated by the painters of the '80s and '90s, Munch among them, who preferred to spend their winters in climates warmer than Norway's. Although the paintings Nansen took to the Arctic were summer scenes, his book glorified winter: snow, ice, darkness, cold, silence, and emptiness. The barren arctic landscape provided the backdrop and opportunity for astounding feats of heroism, such as face-to-face combat with polar bears, and brute endurance of freezing temperatures, piercing wet, and near starvation. Nansen attributed his survival against these odds to his conditioning and heritage as a Norwegian; unlike the English, French, and American explorers, he and his crew had known arctic conditions since birth and were better prepared to triumph over them. Enhancing each individual's personal strength, he believed, was Norway's Viking history.

Nansen pursued his nationalistic agenda not only in his writing but also dur-

ing the voyage of the *Fram* itself, with the enthusiastic assistance of his equally patriotic crew. Thus on May 17, 1894, the eightieth anniversary of the Norwegian constitution (the first modern document proclaiming Norway's independence), crew members and sled dogs were decorated with ribbons and bows and a parade was launched on the ice.

> The wind whistled, and the Norwegian flag floated on high, fluttering bravely at the masthead. About 11 o'clock the company assembled with their banners on the ice on the port side of the ship, and the procession arranged itself in order. First of all came the leader of the expedition with the "pure" Norwegian flag; after him Sverdrup with the *Fram*'s pennant, which, with its "FRAM" on a red ground, 3 fathoms long, looked splendid. Next came a dog-sledge, with the band (Johansen with the accordion), and Mogstad, as coachman; after them came the mate with rifles and harpoons, Henriksen carrying a long harpoon; then Amundsen and Nordahl, with a red banner. The doctor followed, with a demonstration flag in favor of a normal working-day. It consisted of a woollen jersey, with the letters "N. A." embroidered on the breast, and at the top of a very long pole it looked most impressive. After him followed our *chef*, Juell, with "peik's" saucepan on his back; and then came the meteorologist, with a curious apparatus, consisting of a large tin scutcheon, across which was fastened a red band, with the letters "Al. St.," signifying "almindelig stemmeret," or "universal suffrage."[59]

The Norwegian flag unfurled on this occasion was a "pure" flag similar to the one Munch flew at the entrance to his second exhibition in Berlin. Nansen's careful descriptions of this and similar events, accompanied by photographic illustrations in the book, prove that he understood their value as nationalist propaganda.

Nansen's Viking revival became a singularly successful Norwegian cultural movement. This movement already had received impetus from the eight-volume history of Norway before 1397 written by Munch's uncle Peter Andreas Munch (published 1851–1863) and from Ibsen's Viking plays *The Vikings at Helgeland* (1857) and *The Pretenders* (1863).[60] In 1880 came the discovery of a ninth-century Viking ship at Gokstad, followed by the successful voyage of its replica from Norway to America in 1893. In the field of exploration, Nansen's fellow Norwegian Roald Amundsen led an expedition through the Northwest Passage in 1903–1906 and in 1911 became the first

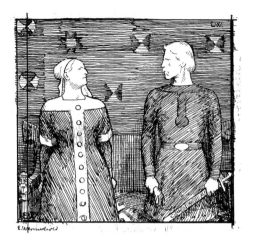

Figure 41. ERIK WERENSKIOLD. Illustration for Snorri Sturluson, *Olav Trygveson's Saga*, 1897. Pen and ink, 14.3×16.6 cm (5⅝×6⁹⁄₁₆ in.). Oslo, Nasjonalgalleriet B.5046.

person to reach the South Pole. Nansen used his renown as an explorer to promote his dream of political separation from Sweden, becoming a prominent spokesman for the independence movement. In 1905 he was sent to England to marshal support for the final break, and he wrote another book, *Norway and the Union with Sweden*,[61] to justify Norway's decisive action later that year. In the field of art, Nansen's close friends and neighbors in the Christiania suburb of Lysaker, Erik Werenskiold, Gerhard Munthe, and others, invented the so-called Snorri or Saga style of drawing (see fig. 41) specifically for the portrayal of Viking history. Nansen himself adopted the spare, linear, black-and-white technique in the illustrations for his book published in 1911, *In Northern Mists*, a history of arctic exploration before the sixteenth century.[62] He was finally enshrined as Norway's modern Viking hero when the *Fram* was retired from active service and placed on public display near the Viking ships from Gokstad and Oseberg (the latter was discovered in 1904).

Munch never succumbed to hero worship of Nansen and his Viking forefathers, nor did he share Knut Hamsun's vehement jealousy of Nansen's cultural leadership. Munch did begin to show an interest in Viking history, however, visiting the Oseberg site when the ship grave was excavated. He also remained in contact with Nansen, borrowing *Starry Night* to include it (for example) in the exhibition of con-

temporary Scandinavian art sent to the United States in 1912–1913, and in his own retrospective in Berlin and Oslo in 1927.[63] In 1902 Nansen acted as guarantor of a bank loan for Munch, enabling him to free pictures from a creditor to send to an exhibition. More surprisingly, Munch sometimes identified himself, in the third person, as "Nansen" in a semi-autobiographical manuscript scrapbook entitled *The Tree of Knowledge*, dated 1915.[64] Munch may have taken the name from Herman Colditz's novel *Kjaerka, A Studio Interior* (1889), in which the artist appears thinly disguised as a character named Nansen. However, by 1915 (if not by 1888), the identification of the name with the arctic explorer and international statesman would have been unavoidable. In *The Tree of Knowledge*, Munch alternates between the names "Nansen" and "Brand," the latter taken from the heroic, doomed priest of Henrik Ibsen's 1866 play of the same name. Munch's choice of names reveals his identification with these two Norwegian heroes: loners, explorers, adventurers willing to make enormous sacrifices in their quest for higher truth—heroes of modern Norwegian life.

Perhaps the patriotic glorification of the Norwegian winter landscape influenced Munch's interest in a new type of composition: the nocturnal snow scene. The earliest examples by him date from 1900–1901, during the winter he spent on the island of Nordstrand, by the North Sea. Unlike *Starry Night*, his winter landscapes are pure visions of nature, celebrating its beauty, strength, and grandeur. The monumental *White Night* (fig. 42) divides the terrain into two parts: the richly forested hills and coastline in the foreground, and dazzling blank expanses of ice and sky in the distance. The composition draws the eye inexorably through the forest and down to the ice, toward the horizon, as if Munch were trying to express in paint the Norwegian yearning for discovery and adventure described by Nansen in his introduction to *Farthest North*.

Eight years after he painted *White Night*, Munch settled permanently in Norway, although he continued to travel extensively on the Continent. He had spent the previous year in Denmark recuperating from a breakdown and alcoholism; the disastrous pace of his life had exhausted him completely. For the moment Norway had become a more attractive place to him. Norwegian collectors were beginning to buy his work, director Jens Thiis bought an important group of paintings for the national

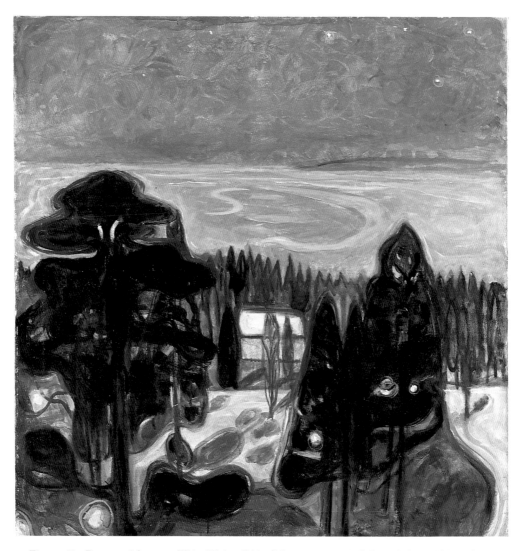

Figure 42. EDVARD MUNCH. *White Night*, 1901. Oil on canvas, 115.5×110.5 cm (45½×43½ in.). Oslo, Nasjonalgalleriet 581.

gallery, and Munch entered, and eventually won, the largest-ever art competition in Norway, for the mural decoration of the Aula, or festival hall, of Oslo's university. In 1908, the year of the national gallery purchase, he was made a Knight of the Royal Order of Saint Olav, a signal honor. Searching for a studio space in which to work, Munch settled first in Kragerø, a town discovered and painted in the '80s by his old mentor Fritz Thaulow, and then bought a house at Hvitsten, although he would continue to visit and work in Kragerø until 1916, and at Åsgårdstrand as well.

Once committed to living permanently in Norway, Munch sought to develop a style that the Norwegian public would find accessible and pleasing. This search inspired a body of work of varying quality and success. His interest in monumental, decorative painting caused him to strengthen colors and contours, to describe forms clearly, and to reduce symbolism. Like Knut Hamsun, who had inherited Björnsterne Björnson's role as Norway's leading author, Munch began to look outward, rather than inward, for inspiration. Officially recognized as Norway's greatest painter, he self-consciously turned his attention to local subjects—peasants and landscape, for example. Psychological self-portraiture lost its consuming interest now that the artist identified himself more closely with the fashionable international avant-garde. The Kragerø landscapes, like those from Nordstrand ten years earlier, omit the human presence and monumentalize nature. Munch thickened his paint to make dry, textured surfaces that emulated the flat, colorful paintings of the French Postimpressionists but lacked the expressive freedom of the washes and streaks in *Starry Night* and other works of the '90s. The influence of Cézanne's constructivist studies of the great pine tree at Montbriand is evident in one work, *Winter in Kragerø* (1912; Oslo Kommunes Kunstsamlinger M319), in which Munch turned Provençal summer into Norwegian winter simply by altering the color scheme.[65] Another, *Winter Landscape at Kragerø* (1910; Oslo Kommunes Kunstsamlinger RES A12), returned to the plunging diagonal form Munch had first borrowed from Impressionism via Christian Krohg more than twenty years earlier. He also turned back to his mood landscapes for inspiration and, perhaps, for guidance. Consequently, he painted the Kragerø cliff (fig. 43) very much in the form of the Åsgårdstrand coastline he had portrayed earlier in *Starry Night*. In the later painting the cliff has taken on the form of Åsgårdstrand's linden trees, and

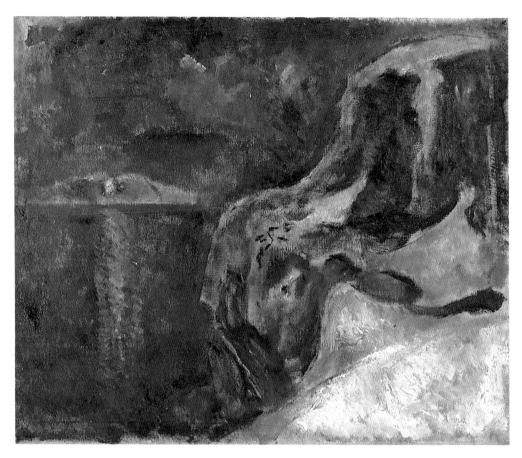

Figure 43. EDVARD MUNCH. *Cliff at Kragerø*, 1910–1914. Oil on canvas, 91×112 cm (35 13/16×44 1/8 in.). Oslo Kommunes Kunstsamlinger M 579.

it is the moon rather than "stars" that casts its light on the sea. Like *Starry Night, Cliff at Kragerø* is a mood landscape, but—stripped of life and harshly painted—it lacks the emotional impact and technical daring of Munch's earlier work. The Kragerø landscapes reflect his concern to keep up with avant-garde painting on the Continent, but they also represent a step backward from the transcendent personal imagery of *Starry Night* and *Attraction I* (fig. 31). To some extent, these relatively disappointing paintings may represent some of Munch's recurring dissatisfaction with Norway itself. Since attaining independence in 1905, the country had entered a period of economic, social, and cultural stagnation that would be exacerbated by the international conflict of World War I, and the artist found himself increasingly isolated and disillusioned.

Searching for new inspiration, Munch turned to the writings of Henrik Ibsen, whom he had first met in 1893 and whose pessimistic views of contemporary Norway and the human condition seemed increasingly appropriate to his own situation. His return to Ibsen also marked his return to the psychological self-portraiture that was the great contribution of Norwegian artists and writers to European modernism. The playwright, though thirty-five years older than the artist, was still the most modern and innovative writer active in Norway, and possibly all of Europe, at the turn of the century. When Munch met him, his genius had been recognized in Germany and France, and he had finally won acceptance in his native country after a struggle with critics and public very similar to Munch's. He and Munch met again in 1895 at an exhibition of the latter's work in Christiania, where Ibsen would have seen The Frieze of Life and *Starry Night*. At the time he was writing a play comparing "the coldness of the heart" to Norway's frozen winter landscape, *John Gabriel Borkman*, published in 1897. Munch probably read the play soon after it was published, for in the same year he designed the advertisement for its French-language production at the Théâtre de l'Oeuvre in Paris (Schiefler 171 A). This lithograph's composition has little to do with the action of the play; it depicts Ibsen in front of a busy harbor dominated by a lighthouse that does not figure in the plot. This work is more about the greatness of the author than about the play itself. Twenty years later Munch's attitude toward Ibsen had shifted, for by then the painter viewed himself as a great Norwegian culture hero, as Ibsen's heir rather than his acolyte. His approach to the dramatist became consid-

Figure 44. EDVARD MUNCH. *After the Battle of Laaka*, 1916–1917. Woodcut. Oslo Kommunes Kunstsamlinger G/t 661.

erably less respectful than it had been in the '90s. He did not hesitate to bend Ibsen's themes to his own expressive purposes, and in confronting the agonies and insoluble problems of Ibsen's work, he rediscovered the emotional energy that had driven him to paint The Frieze of Life.

In 1916 Munch began to illustrate *The Pretenders*, a historical drama Ibsen wrote in 1863 to protest Norway's failure to support Denmark in a conflict against Germany. The play's tone and subject suited Munch's deeply pessimistic response to the First World War, in which his country was weakly neutral. While Ibsen set *The Pretenders* in thirteenth-century Norway, his presentation of the Viking kings is less than heroic. The main character, Skule, is a proud and ambitious man fatally incapable of taking action in a crisis, so he loses his crown to a less talented but more decisive pretender. By selecting Ibsen's modernized, pessimistic version of the sagas, Munch

diverged from Fridtjof Nansen's optimistic but increasingly nostalgic Viking revival. In a like manner, his brutal woodcut technique contrasted with the tidy, historicist Saga style. Even the episodes Munch selected for illustration, such as the withdrawal of Skule's defeated troops in *After the Battle of Laaka* (fig. 44), are unheroic and tragic.

Munch's bleak view of the war was also reflected in changes in his view of nature, specifically in his tree imagery. The green, growing trees of *Starry Night* and *Eye in Eye* (fig. 28) were symbols of life, unity, and regeneration. In figural treatments of the theme of rebirth, notably *Adam and Eve* of 1908 and *Metabolism* (1898; reworked 1918; Oslo Kommunes Kunstsamlinger OKK M419), the fruiting tree represented fertility and transmutation. In one version of *Metabolism* (fig. 45), the tree literally feeds upon a desiccated corpse, and flowers grow from the skulls of animals, changing death into life. The composition echoes the Norse creation myth, with the transformation of the body of the fallen giant, Ymir, into the world of man. By 1911, in the Aula decorations, Munch was painting great trees presiding over figures personifying History and Alma Mater. Their enormous roots delve into the earth, and their rich foliage reaches the sky. These monumental trees recall Yggdrasil, the World Tree of German and Scandinavian mythology, which stood in the center of the universe and linked together the regions of the gods, the giants, and the dead beneath its roots. Yggdrasil stretched like a giant ladder from the underworld to the world of men to heaven. However, Munch's prints grouped under the title The Tree of Life (see fig. 46) show the world's metabolism thrown out of balance by war.[66] Corpses pile up beneath the World Tree, whose branches are nearly bare. In the once-verdant landscape grow grave markers—a veritable city of the dead—and in a version with an arched top, the tree is equated with a crucifix. Thus the tree, once part of the natural, regenerative process, is now the site of death and sacrifice, unable to mediate between death and life.

While Munch's tree imagery became increasingly barren, the red house, microcosmic symbol of domesticity in *Starry Night*, grew into a city reminiscent of the distant one depicted in Friedrich's *Greifswald in Moonlight* (fig. 16). The proliferation of houses behind a tree had first occurred in Munch's oeuvre in one of the central Frieze of Life paintings, *Ashes* (1894; Oslo, Nasjonalgalleriet). "It is a picture of life as well as of death, it shows the wood feeding off the dead and the city growing up

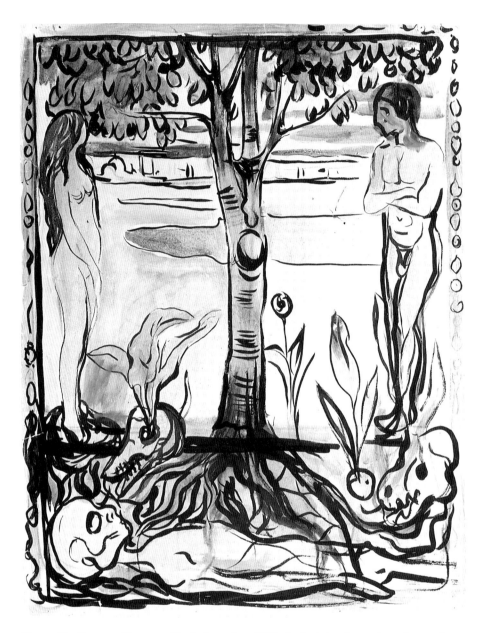

Figure 45. EDVARD MUNCH. *Metabolism*, circa 1898. India ink, charcoal, and gouache on paper, 64.7 × 49.7 cm (25½ × 19⁹⁄₁₆ in.). Oslo Kommunes Kunstsamlinger T 2447.

Figure 46. EDVARD MUNCH. *The Tree of Life—The Cross*, 1915(?). Lithograph. Oslo Kommunes Kunstsamlinger G/l 441.1.

behind the trees. It is a picture of the powerful constructive forces of life," Munch wrote much later.[67] Returning to Åsgårdstrand, Munch depicted numerous roofs of houses, not just the red house, within the form of the clump of lindens in a late (1916) drawing of the Kiøsterudgården trees as seen from the pier (fig. 47). Seventeen years after *Ashes*, what Munch now called "the golden city"[68] appeared as a yellow glow behind Adam and Eve figures in one of the Aula decorations, *New Rays*, but became a cemetery in the pessimistic Tree of Life prints.

The pessimism of wartime persisted after Munch began to illustrate Ibsen's *John Gabriel Borkman* in 1916. The play is about a banker who has squandered and lost everything in the blind pursuit of a mining empire. On the last evening of his life, his family and friends assemble for the first time since the exposure of his financial spec-

ulations many years before. The bitter revelations of that evening, as each character accuses the others of killing his or her deepest desires, end with Borkman fleeing the house, exchanging the "coldness of the heart" indoors for the fatal chill of the Norwegian winter night. In the final act he dies on a bench on a snowy hill overlooking the fjord as his wife and her twin sister watch.

John Gabriel Borkman resembles Ibsen's earlier play *Brand* in that the heroes of both reject the love of women, family, and compatriots in order to pursue what they mistakenly believe to be higher goals. Both men die—symbolically and actually—of the cold, Borkman on a snowy hill, Brand in an avalanche. Munch seems to have identified with both characters because of his own inability to love any one woman, even to contemplate family life or to maintain close friendships. Believing that he had rejected love in order to pursue his art, he identified himself as "Brand" in *The Tree of Knowledge*. Then, in one of his Borkman illustrations, he portrayed the dead financier with his own features (fig. 48). Moreover, in a remark that directly compares *John Gabriel Borkman* to the themes of his own paintings, Munch called the play "the most powerful winter landscape in Scandinavian art."[69]

Several of Munch's *Borkman* illustrations represent the banker dead in the snow attended by the two sisters, the penultimate scene of the fourth act:

Ella: I think it was the cold that killed him.

Mrs. Borkman: The cold? That killed him long ago.

Ella: And turned us into shadows.

Mrs. Borkman: Yes.

Ella: One dead man and two shadows. See what the cold has done.

Mrs. Borkman: Yes. The coldness of the heart. And now I think we two can join hands, Ella.

Ella: I think we can, now.

Mrs. Borkman: We twin sisters—over the man we both loved.

Ella: We two shadows—over the dead man.[70]

In the illustration entitled *Starry Night* (fig. 49), Borkman lies dead on a bench in the right foreground, and the snowy hill, dead trees, and distant panorama correspond generally to Ibsen's stage directions:

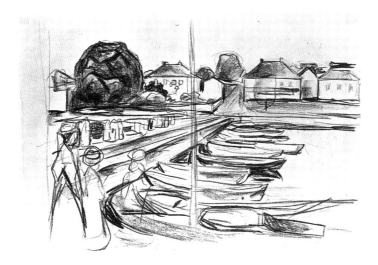

Figure 47. EDVARD MUNCH. *The Jetty in Åsgårdstrand*, 1916. Charcoal on paper. Oslo Kommunes Kunstsamlinger T 2388.

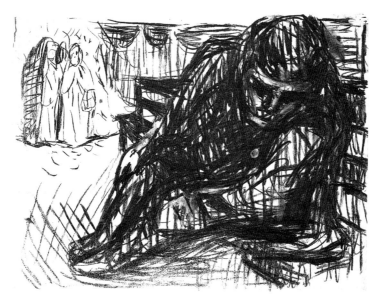

Figure 48. EDVARD MUNCH. *"Here he is, Gunhild"* (scene from *John Gabriel Borkman*), 1916–1923. Charcoal on paper, 48×65 cm (18⅞×25⁹⁄₁₆ in.). Oslo Kommunes Kunstsamlinger T 2116.

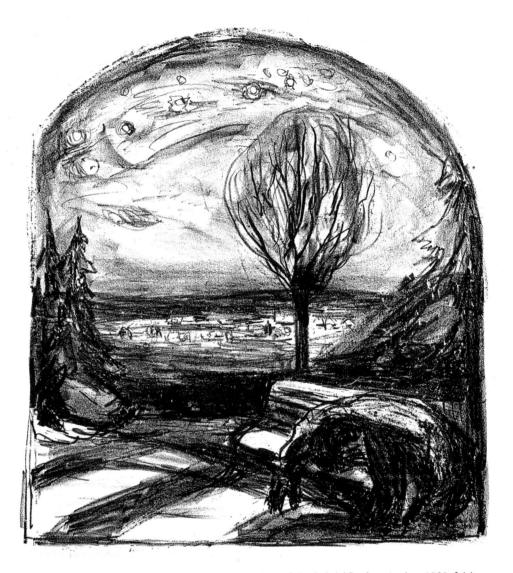

Figure 49. EDVARD MUNCH. *Starry Night* (scene from *John Gabriel Borkman*), circa 1920. Lithograph, 40.3×37.3 cm (15⅞×14¹¹⁄₁₆ in.). Oslo Kommunes Kunstsamlinger G/l 497-2.

The snow has stopped, but the ground is covered with a deep layer of freshly fallen snow. The pines are heavily bowed with it. Dark night sky, with driving clouds. The moon can be vaguely glimpsed from time to time. The only illumination comes from the light reflected from the snow . . .

 . . . a small clearing high up in the forest. The mountain rises steeply behind them. To the left, far down, can be seen a vast landscape, with fjords, and high distant peaks rising one behind another. To the left of the clearing is a dead pine tree with a seat beneath it. Snow lies deep on the ground.[71]

The discrepancies between Ibsen's stage directions and Munch's image are small but significant. In the latter the dead tree is not a pine, the night sky is clear and full of stars, and the women appear only as shadows.

All of these differences link the lithograph illustration to the Getty Museum's *Starry Night* painting (perhaps Munch's greatest summer landscape) and to the *Attraction I* print (fig. 31). (The illustration's arched top relates it directly to the latter.) The shape of the dead tree is reminiscent of the living tree in *Eye in Eye* (fig. 28), evocative of the gardens of Eden and Midgård. Juxtaposed with Borkman's collapsed body, it symbolizes the end of the regenerating process celebrated in *Metabolism* (fig. 45) and threatened with extinction in the Tree of Life series (see fig. 46). Its barrenness is the key to Munch's transformation of *Starry Night* from an image of passionate union and the continuity of life into a meditation on death and sterility. Even the life-giving rays of the sun from the Tree of Life series have been replaced by night. Both Ibsen's staging of *Borkman*'s final scene and Munch's illustration of it allude to the vision of the end of the world described in Norse mythology. The doom of the gods (*Götterdämmerung* in German, *Ragnarok* in Norwegian) is signaled when Yggdrasil begins to tremble; it is predicted by three years of winter, by human wickedness, suffering, and warfare, and by the darkening of the sun.

The combination of World War I and his interest in *Borkman* revived the *Starry Night* composition for Munch, but as a symbolist winter scene rather than a summer mood landscape. Even after the war ended and Norway and the world returned to political stability, Munch continued to work with the *Starry Night* concept in its new role as a prediction of apocalyptic doom, transforming it from its state as an illustration

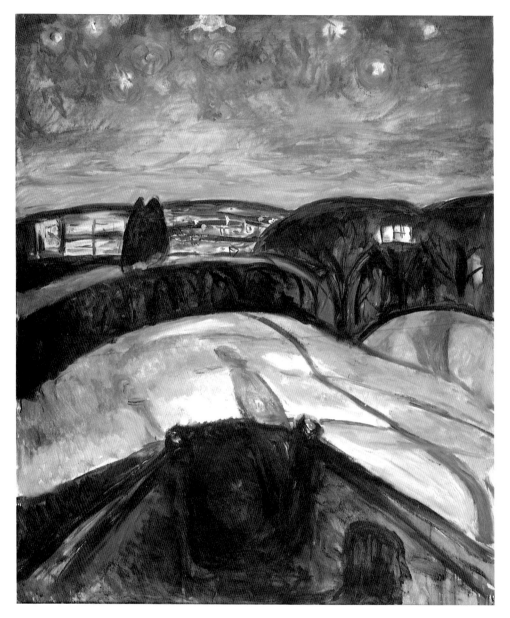

Figure 50. EDVARD MUNCH. *Starry Night*, circa 1923–1924. Oil on canvas, 118.5×98 cm (46⅝×38⁹⁄₁₆ in.). Oslo Kommunes Kunstsamlinger M 32.

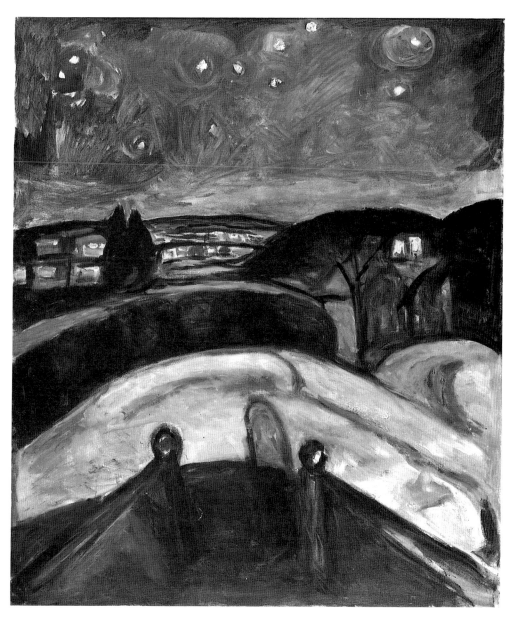

Figure 51. Edvard Munch. *Starry Night*, 1923–1924. Oil on canvas, 121×100 cm (47⅝×39⅜ in.). Oslo Kommunes Kunstsamlinger M 9.

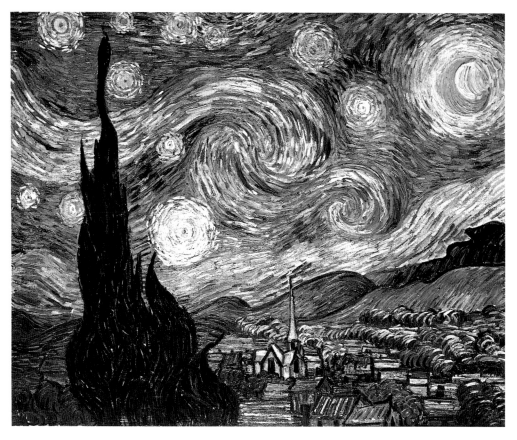

Figure 52. VINCENT VAN GOGH. *The Starry Night*, 1889. Oil on canvas, 73.7 × 92.1 cm (29 × 36¼ in.). New York, Museum of Modern Art, acquired through the Lillie P. Bliss Bequest, 472.41.

of Ibsen's play into a personal statement about his own loneliness and anxiety. As part of this process of personalization, the late *Starry Night* paintings (figs. 50, 51) borrowed and reinterpreted the symbolic elements of the Getty Museum's landscape.

Edvard Munch painted his two late *Starry Night*s between 1923 and 1924 and never parted with them. Both show the view from the front door or verandah of his house looking toward a golden town. It is the same view Munch had modified to match Ibsen's stage directions for the *Borkman Starry Night* lithograph (fig. 49). Stripped of

88

Figure 53. EDVARD MUNCH. *Starry Night* (scene from *John Gabriel Borkman*), 1916–1923. Charcoal on paper, 70×62.5 cm (27⁹⁄₁₆×24⅝ in.). Oslo Kommunes Kunstsamlinger T 2421.

Figure 54. EDVARD MUNCH. *Winter: Ekely* (*Blue Starry Night*), 1923–1924. Oil on canvas, 100×80 cm (39⅜×31½ in.). Oslo Kommunes Kunstsamlinger M 190.

its stage props, the landscape had become as intimately connected with the artist as the more familiar terrain in Åsgårdstrand had earlier. Pictorial devices from the Åsgårdstrand *Starry Night* abound: for example, the plunging diagonal fence has its counterpart in the staircase railing, which leads the eye into the middle distance. A light gleams through the distant clump of trees, although now it is lamplight, not moonlight. The stars in the sky are larger, more thickly painted, and more heavily ringed with halos of light than those in the earlier landscapes. Quite possibly the great van Gogh *Starry Night* (fig. 52), with its overwhelming sky, influenced Munch's technique in these later pictures. In them, human presence is again suggested only by shadows; in a contemporary drawing (fig. 53) and in one of the two late oils, three shadows appear just as in one of the *Borkman* illustrations. In one of the late paintings (fig. 50), two full-length shadows fall on the stairs, and the silhouette of a man's head appears on the railing at the right. One cannot be sure to whom these shadows belong, although the profile may well be Munch's. Perhaps they refer to the lines from Ibsen's play, spoken by Ella Rentheim, "One dead man and two shadows. See what the cold has done." The other late version (fig. 51) contains only one shadow, presumably cast by the artist standing in front of his illuminated house. He is now totally alone, as in the much earlier painted version now in Wuppertal (fig. 33).

In other ways, Munch's late *Starry Nights* relate to the even earlier *Night in Saint-Cloud* (fig. 13) and its meditation on isolation and death. The artist's profile shadow on the verandah railing may recall the figure silhouetted against the window in the earlier picture. Moreover, the view in each of these paintings looks toward the lights of human habitation set at a seemingly impassable distance from the solitary figure. In two compositions from the last phase of the theme, called *Winter: Ekely* (see fig. 54), the barren trees block access to the familiar, brightly lit red house that is each composition's focus. Thus the late *Starry Nights* redraw Munch's early comparison between the isolated artist/hero's confrontation with darkness and death, and the cheerful warmth of masses of conventional humanity, far away. Nature in these pictures forms a barrier, physical and symbolic, between the artist and the glowing city. The cold, snow, forest, and steep hills block his route, in contrast to the Åsgårdstrand *Starry Night*, in which all the forces of nature conspire to draw two lovers together.

NOTES

1. R. Stang, *Edvard Munch: The Man and His Art*, trans. G. Culverwell (New York, 1977), p. 15.

2. *Hovedstrømninger i det 19.aarhundredes literatur* (G. M. C. Brandes, *Samlede skrifter* [Copenhagen, 1899–1919], vols. 3–6). See R. Dittmann, *Eros and Psyche: Strindberg and Munch in the 1890s* (Ann Arbor, 1982), p. 80.

3. M. Jacobs, *The Good and Simple Life: Artist Colonies in Europe and America* (Oxford, 1985), p. 88.

4. K. Varnedoe, "Christian Krohg and Edvard Munch," *Arts Magazine* 53, no. 8 (April 1979), p. 89.

5. A. Eggum, *Edvard Munch: Paintings, Sketches and Studies*, trans. R. Christophersen (New York, 1984), p. 39.

6. B. Torjusen, *Words and Images of Edvard Munch* (Chelsea, Vt., 1986), p. 76. Torjusen was the first to connect this prose poem with the Museum's *Starry Night*.

7. H. Usselmann, "Andreas Aubert, un exégète norvégien de l'impressionisme (1883–1884)," *Gazette des Beaux-Arts*, 6th ser., 105, no. 1393 (February 1985), p. 90; M. Malmanger, "'Impressionismen' og *Impressionisten*: Chr. Krohg og det moderne gjennombrudd i 1880-årene," in *Christian Krohg*, exh. cat. (Nasjonalgalleriet, Oslo, 1987), pp. 31–50.

8. *Edvard Munch*, exh. cat. (Kunsthaus, Zurich, 1987), no. 14.

9. A. Eggum, *Munch og fotografi* (Oslo, 1987), chap. 20.

10. See Edvard Munch, *The Seine at St. Cloud*, 1890. Oil on canvas, 46.5×38 cm (18¼×15 in.). Oslo Kommunes Kunstsamlinger OKK M1109. Much more Whistlerian in feeling is the small copper *Seine at St. Cloud* of the same year. Both are illustrated in Eggum (note 5), pp. 64, fig. 108; 65, fig. 109.

11. R. Heller, "Edvard Munch's 'Night,' The Aesthetics of Decadence, and the Content of Biography," *Arts Magazine* 53, no. 2 (October 1978), p. 80.

12. The correct identification was published by D. Koepplin in *Edvard Munch: Sein Werk in Schweizer Sammlungen*, exh. cat. (Kunstmuseum Basel, 1985), p. 68.

13. G. Winkler, *Max Klinger* (Leipzig, 1984), p. 268.

14. S. Mallarmé, *Oeuvres complètes* (Paris, 1945), pp. 37–38.

15. P. D. Bader-Borel, "The Dream: A Recurrent Image in Symbolist and Neo-symbolist Poetry" (Ph.D. diss., New York University, 1984; Ann Arbor, 1986), pp. 89, 115–116, 123.

16. *Alruner: Psykologische dicte.*

17. R. Heller, *Munch: His Life and Work* (Chicago, 1984), pp. 63–64.

18. G. Svenaeus, *Edvard Munch: Im männlichen Gehirn*, 2 vols. (Lund, 1973), vols. 1, 165; 2, 90–91.

19. R. Rosenblum, *Modern Painting and the Northern Romantic Tradition: Friedrich to Rothko* (New York, 1975), p. 108.

20. A. Aubert, "Der Landschaftsmaler Friedrich," trans. Professor Dahl, *Kunstchronik*, 7th year, no. 18 (1895–1896), pp. 285-286.

21. Ibid., p. 291.

22. Heller (note 11), p. 80ff.

23. L. Østby, *Erik Werenskiold* (Oslo, 1977), p. 167; R. Ferguson, *Enigma: The Life of Knut Hamsun* (New York, 1987), p. 119.

24. *Fra det ubevidste sjaeleliv*, in K. Hamsun, *Artikler, i utvalg ved Franus Bull* (Oslo, 1939); quoted here from Ferguson (note 23), pp. 117–118.

25. Stang (note 1), p. 90.

26. K. Hamsun, *Mysteries*, trans. A. G. Chater (New York and London, 1927), pp. 106–107.

27. Ferguson (note 23), p. 131.

28. R. Stenersen, *Edvard Munch: Close-up of a Genius*, trans. R. Dittmann (Oslo, 1969), p. 52.

29. A. Eide, *Åsgårdstrand: Om hvite hus og løv-kroner spredt historikk* (Bergen, 1946), pp. 79–85.

30. I. A. Gløersen, *Lykke huset: Edvard Munch og Åsgårdstrand* (Oslo, 1970), p. 61.

31. Ibid., p. 64.

32. My thanks to E. Wilson for his translation.

33. Eggum (note 9), pp. 55–65.

34. Ibid., pp. 60–61.

35. Eide (note 29), pp. 112–114.

36. L. Østby, *Fridtjof Nansen som kunstner* (Oslo, Bergen, and Tromsø, 1980), p. 16.

37. See A. Boime, "Van Gogh's *Starry Night*: A History of Matter and a Matter of History," *Arts Magazine* 59, no. 4 (December 1984), p. 88.

38. I am deeply indebted to A. Eggum for pointing out the star symbolism in *Starry Night* during his visit to Malibu in November 1986. He will publish his views in his book on The Frieze of Life (in preparation).

39. In *Edvard Munch* (New York, 1971), pp. 90–91, T. M. Messer identifies the dot and streak in the trees as a flagpole. A postcard of Åsgårdstrand circa 1902 showing a white flagpole in the Kiøsterudgården supports this idea (see above, fig. 18). However, by 1890 Munch already had developed the dot and streak as a way of representing a light source and its reflection; it seems plausible to identify the motif in the Getty Museum's *Starry Night* as the moon and its reflection seen through trees. This would fit with the description in the prose poem of the hidden moon (see above, p.19), as well as with the changing star symbolism in Munch's later versions of *Starry Night*.

40. Stang (note 1), p. 148.

41. T. Skedsmo, "Tautrekking om Det syke barn," *Kunst og Kultur* 68, no. 3 (1985), p. 184.

42. Dittmann (note 2), p. 81.

43. Stang (note 1), p. 103.

44. R. Heller, "Love as a Series of Paintings and a Matter of Life and Death," in *Edvard Munch: Symbols and Images*, exh. cat. (National Gallery of Art, Washington, D.C., 1978), p. 90.

45. A Love, 1887. Ten etched and engraved plates, some with aquatint, each image approx. 40.5×26.5 cm (16×10½ in.).

46. Torjusen (note 6), p. 70.

47. A. Eggum, "Anziehung," in *Edvard Munch: Liebe. Angst. Tod*, exh.cat. (Kunsthalle Bielefeld and other institutions, 1980), pp. 79–86.

48. Torjusen (note 6), p. 78.

49. Stenersen (note 28), p. 53.

50. Snorri Sturluson, *The Prose Edda*, trans. A. G. Brodeur (1916; New York, 1967), p. 21.

51. Skedsmo (note 41), p. 184.

52. *Fram over Polhavet*.

53. F. Nansen, *Farthest North*, 2 vols. (New York, 1932), vol. 1, pp. 54–55.

54. Ibid., vol. 1, pp. 368–369, 502.

55. T. Skedsmo, "Hos kunstnere, polarforskere og mesener," *Kunst og Kultur* 65, no. 3 (1982), pp. 131–136, 141–144.

56. Nansen (note 53), vol. 1, pp. 361, 424.

57. Ibid., vol. 1, p. 386.

58. J. House, "An Outside View," in *Dreams of a Summer Night: Scandinavian Painting at the Turn of the Century*, exh. cat. (Hayward Gallery, London, 1986), pp. 20–22.

59. Nansen (note 53), pp. 483–484.

60. *Haermaendene på Helgeland* and *Kongs-emnerne*; see H. Ibsen, *Samlede vaerker*, vol. 2 (Copenhagen, 189x).

61. *Norge og foreningen med Sverige* (Kristiania, 1905).

62. *Nord i Tåkeheimen*; see Østby (note 36), pp. 21–22.

63. The most complete listing of *Starry Night*'s early exhibition history appears in S. Willoch et al., *Edvard Munch*, exh. cat. (Solomon R. Guggenheim Museum, New York, 1965), no. 21. Its association with the Frieze is thoroughly discussed in Heller (note 44), pp. 87–112. However, in the same publication, in his catalogue entry on *Starry Night* (p. 42), A. Eggum disagrees with Heller over its presence in the 1902 Berlin Secession exhibition, stating that *Starry Night*, rather than *The Voice*, should be identified with cat. no. 187 in that exhibition's catalogue, *Evening Star*. Questions have also arisen about whether the *Starry Night* in some of these exhibitions might be the version in Wuppertal (see above, fig. 33) rather than that in the Getty Museum.

64. *Kunskabens trae paa godt og ondt*; see G. Woll, "The Tree of Knowledge of Good and Evil," in *Edvard Munch: Symbols and Images* (note 44), p. 229.

65. Compare, for example, with Cézanne's *Great Pine and Red Earth* of 1885–1887 (Venturi 458).

66. See also Edvard Munch.*Tree of Life*, 1915. Lithograph, approx. 21.2×35.5 cm (8¾×14 in.) (Schiefler 433).

67. Stang (note 1), p. 116.

68. Ibid., p. 235.

69. H. Ibsen, *The Plays*, trans. M. Meyer, vol. 1 (New York, 1986), p. 303.

70. Ibid., vol. 1, p. 389.

71. Ibid., vol. 1, pp. 377, 386.

BIBLIOGRAPHY

1880-tal i nordiskt maleri. Exh. cat. Nasjonalgalleriet, Oslo, 1985.

Aubert, A. *Caspar David Friedrich "Gott, Freiheit, Vaterland."* Trans. L. Wolf. Berlin, 1915.

————. "Der Landschaftsmaler Friedrich." Trans. Professor Dahl. *Kunstchronik,* 7th year, no. 18 (1895–1896), pp. 281–293.

Bader-Borel, P. D. "The Dream: A Recurrent Image in Symbolist and Neo-symbolist Poetry." Ph.D. diss., New York University, 1984; Ann Arbor, 1986.

Bock, H., and G. Busch, eds. *Edvard Munch: Probleme—Forschungen—Thesen.* Munich, 1973.

Boime, A. "Van Gogh's *Starry Night*: A History of Matter and a Matter of History." *Arts Magazine* 59, no. 4 (December 1984), pp. 86–103.

Börsch-Supan, H., and K. Wilhelm Jähnig. *Caspar David Friedrich: Gemälde, Druckgraphik und bildmäßige Zeichnungen.* Munich, 1973.

Brøndsted, J. *The Vikings.* New York, 1965.

Christian Krohg. Exh. cat. Nasjonalgalleriet, Oslo, 1958.

Christian Krohg. Exh. cat. Nasjonalgalleriet, Oslo, 1987.

Corn, W. M. *The Color of Mood: American Tonalism 1880–1910.* Exh. cat. M. H. de Young Memorial Museum and California Palace of the Legion of Honor, San Francisco, 1972.

Dember, W. V. *Visual Perception: The Nineteenth Century.* New York, 1964.

Derry, T. K. *A History of Modern Norway 1814–1972.* Oxford, 1973.

Dittmann, R. *Eros and Psyche: Strindberg and Munch in the 1890s.* Ann Arbor, 1982.

Dorra, H. "Munch, Gauguin and Norwegian Painters in Paris." *Gazette des Beaux-Arts,* 6th ser., 88, no. 1294 (November 1976), pp. 175–180.

Dreams of a Summer Night: Scandinavian Painting at the Turn of the Century. Exh. cat. Hayward Gallery, London, 1986.

Edvard Munch. Exh. cat. Galerie Beyeler, Basel, 1965.

Edvard Munch. Exh. cat. Kunsthaus, Zurich, 1987.

Edvard Munch: Liebe. Angst. Tod. Exh. cat. Kunsthalle Bielefeld and other institutions, 1980.

Edvard Munch: Sein Werk in Schweizer Sammlungen. Exh. cat. Kunstmuseum Basel, 1985.

Edvard Munch: Symbols and Images. Exh. cat. National Gallery of Art, Washington, D.C., 1978.

Eggum, A. *Der Linde-Fries: Edvard Munch und sein erster deutscher Mäzen, Dr. Max Linde.* Exh. cat. Der Senat der Hansestadt Lübeck, 1982.

————. *Edvard Munch: Paintings, Sketches and Studies.* Trans. R. Christophersen. New York, 1984.

————. *Munch og fotografi.* Oslo, 1987.

Eide, A. *Åsgårdstrand: Om hvite hus og løvkroner spredt historikk.* Bergen, 1946.

Eitner, L. "The Open Window and the Storm-Tossed Boat: An Essay in the Iconography of Romanticism." *Art Bulletin* 37, no. 4 (December 1955), pp. 281–290.

Ferguson, R. *Enigma: The Life of Knut Hamsun.* New York, 1987.

From Realism to Symbolism: Whistler and His World. Exh. cat. Philadelphia Museum of Art, 1971.

Gløersen, I. A. *Lykke huset: Edvard Munch og Åsgårdstrand.* Oslo, 1970.

Greve, T. *Fridtjof Nansen 1861–1904.* Oslo, 1973.

Hamsun, K. *Mysteries.* Trans. A. G. Chater. New York and London, 1927.

Hasund Langballe, A. M., and G. Danbolt. *Bibliography of Norwegian Art History: Literature on Norwegian Art Published up to the End of 1970.* Oslo, Bergen, and Tromsø, 1976.

Heller, R. "Edvard Munch's 'Night,' The Aesthetics of Decadence, and the Content of Biography." *Arts Magazine* 53, no. 2 (October 1978), pp. 80–105.

————. *Munch: His Life and Work.* Chicago, 1984.

Hoeyer, L. *Nansen: A Family Portrait*. London, New York, 1957.

Hougen, P., and U. Perucchi-Petri. *Munch und Ibsen*. Exh. cat. Kunsthaus, Zurich, 1976.

Ibsen, H. *The Plays*. Trans. M. Meyer. 5 vols. to date. New York, 1986–.

Jacobs, M. *The Good and Simple Life: Artist Colonies in Europe and America*. Oxford, 1985.

Krieger, P. *Edvard Munch: Der Lebensfries für Max Reinhardts Kammerspiele*. Exh. cat. Nationalgalerie, Berlin, 1978.

Langaard, J. H., and R. Revold. *Edvard Munch fra år til år*. Oslo, 1961.

Lathe, C. *Edvard Munch and His Literary Associates*. Exh. cat. University of East Anglia and other institutions, 1979.

Lind, I. "The Origin of the Image of Scandinavia in the U.S.A.: The 1912 Exhibition of Danish, Norwegian, and Swedish Art." *Scandinavian Review* (Winter 1985), pp. 35–49.

Mallarmé, S. *Oeuvres complètes*. Paris, 1945.

Messer, T. M. *Edvard Munch*. New York, 1971.

Nansen, F. *Farthest North*. 2 vols. New York, 1932.

Nasgaard, R. *The Mystic North: Symbolist Landscape Painting in Northern Europe and North America 1890–1940*. Exh. cat. Art Gallery of Ontario, Toronto, 1984.

Østby, L. *Erik Werenskiold*. Oslo, 1977.

———. *Fridtjof Nansen som kunstner*. Oslo, Bergen, and Tromsø, 1980.

Rosenblum, R. "Edvard Munch's *Starry Night*." Lecture presented at the J. Paul Getty Museum, Malibu, January 29, 1987.

———. *Modern Painting and the Northern Romantic Tradition: Friedrich to Rothko*. New York, 1975.

Schiefler, G. *Verzeichnis des graphischen Werks Edvard Munch*. Vol. 1, Berlin, 1907; vol. 2, Leipzig, 1928.

Schneede, U. M. *Edvard Munch Das kranke kind: Arbeit an der Erinnerung*. Frankfurt, 1984.

Skedsmo, T. "Hos kunstnere, polarforskere og mesener." *Kunst og Kultur* 65, no. 3 (1982), pp. 131–151.

———. "Tautrekking om Det syke barn." *Kunst og Kultur* 68, no. 3 (1985), pp. 184–195.

Smith, J. B. "August Strindberg's Visual Imagination." *Apollo* 112, no. 104 (October 1970), pp. 290–297.

Stang, R. *Edvard Munch: The Man and His Art*.

Trans. G. Culverwell. New York, 1977.

Stenersen, R. *Edvard Munch: Close-up of a Genius*. Trans. R. Dittmann. Oslo, 1969.

Stevens, R. "Munch in America . . . echoes of 1912 . . ." *Art News* 64, no. 9 (1965–1966), pp. 41–43.

Strindberg, A. "Du Hasard dans la production artistique." *La Revue des revues* 11 (1948), pp. 265–270.

Sturluson, Snorri. *The Prose Edda*. Trans. A. G. Brodeur. 1916; New York, 1967.

———. *The Stories of the Kings of Norway Called the Round World*. Trans. W. Morris and E. Magnússon. 4 vols. London, 1893–1905.

Svenaeus, G. *Edvard Munch: Im männlichen Gehirn*. 2 vols. Lund, 1973.

Thue, O. "Edvard Munch og Christian Krohg." *Kunst og Kultur* (1973), pp. 237–256.

Torjusen, B. *Words and Images of Edvard Munch*. Chelsea, Vt., 1986.

Turville-Petre, E. O. G. *Myth and Religion of the North: The Religion of Ancient Scandinavia*. 1964; repr. Westport, 1975.

Usselmann, H. "Andreas Aubert, un exégète norvégien de l'impressionisme (1883–1884)." *Gazette des Beaux-Arts*, 6th ser., 105, no. 1393 (February 1985), pp. 89–96.

Varnedoe, K. "Christian Krohg and Edvard Munch." *Arts Magazine* 53, no. 8 (April 1979), pp. 88–95.

———. *Northern Light: Realism and Symbolism in Scandinavian Painting 1880–1910*. Exh. cat. Corcoran Gallery of Art, Washington, D.C., 1982.

Venturi, R. *Cézanne—son art et son oeuvre*. 2 vols. Paris, 1936.

Willoch, S., et al. *Edvard Munch*. Exh. cat. Solomon R. Guggenheim Museum, New York, 1965.

Winkler, G. *Max Klinger*. Leipzig, 1984.

Wright, C. J. "The Spectre of Science: The Study of Optical Phenomena and the Romantic Imagination." *Journal of the Warburg and Courtauld Institutes* 43 (1980), pp. 186–200.

Young, A. McL., et al. *The Paintings of James McNeill Whistler*. 2 vols. New Haven and London, 1980.

ACKNOWLEDGMENTS

Anyone attempting to write about Edvard Munch while living in Southern California must owe a greater debt than usual to scholars of nineteenth-century Northern painting, and to Munch specialists in particular. The author wishes to acknowledge Arne Eggum's generosity with facts and ideas that have proved crucial to understanding *Starry Night*. Reinhold Heller has provided information and encouragement since the acquisition of the painting in 1984, and his criticism of the manuscript led (I hope) to many improvements in the text. In 1987 Robert Rosenblum's lecture on *Starry Night* delivered at the Getty Museum stimulated my thinking about the painting's European context. My thanks to him for his generous comments on the manuscript. Stephen Eisenman also served as a reader and provided useful suggestions. To Jane van Nimmen I owe my interest in Fridtjof Nansen as well as important bibliography on *Starry Night* and its first owner. Finally, I would thank Eric Wilson and Anna Wohl, whose fine translations of Norwegian books and articles gave me access to specialized scholarship not available in English.

Many people helped to track down information and photographs I was unable to locate on my own. Special thanks are due to Bente Torjusen, Mrs. Tim Greve, Leif Østby, Pieter Krieger, Alf Bøe, Tone Skedsmo, Mrs. Sally Epstein, and, finally, Deborah Mattsson, who squandered her Christmas vacation trudging around Stockholm in search of Strindberg celestographs.

Last but not least I must thank my colleagues at the Getty Museum whose own work loads increased as a direct consequence of my mental and physical explorations of the Far North. Especially deserving are my friends in the Paintings department, Paintings Conservation, the Library, Photographic Services, and Publications. Thanks also to Tosh, who kept the home fires burning.

The Getty Museum Studies
on Art seek to introduce
individual works of note or
small groups of closely related
works to a broad public with
an interest in the history of art
and related disciplines. Each
monograph features a close
discussion of its subject as well
as a detailed analysis of the
broader context in which the
work was created, considering
relevant historical, cultural,
chronological, and other
questions. These volumes are
also intended to give readers
a sense of the range of
approaches which can be taken
in analyzing works of art
having a variety of functions
and coming from a wide range
of periods and cultures.

Christopher Hudson, Head of Publications
Andrea P. A. Belloli, Series Editor
Patricia Inglis, Designer
Thea Piegdon, Production Artist
Karen Schmidt, Production Manager
Elizabeth Burke Kahn, Photograph Coordinator

Typography by Wilsted & Taylor
Printed by Toppan Printing Co., Ltd.